Hair&Fashion

Hair&Fashion

Caroline Cox Lee Widdows

V&A Publications

First published by V&A Publications, 2005
V&A Publications
160 Brompton Road
London SW3 1HW

Distributed in North America by Harry N. Abrams, Inc.,
New York

ISBN 1 85177 457 2

Library of Congress Control Number 2004111389

A catalogue record for this book is available from the
British Library.

Designed by Vaughan Oliver at v23

Front jacket and chapter divider photography
(except chapter three): Dominic Davies

Printed in China

V&A Publications would like to thank L'Oréal
Professionnel for their support of *Hair and Fashion*.

V&A Publications
160 Brompton Road
London SW3 1HW
www.vam.ac.uk

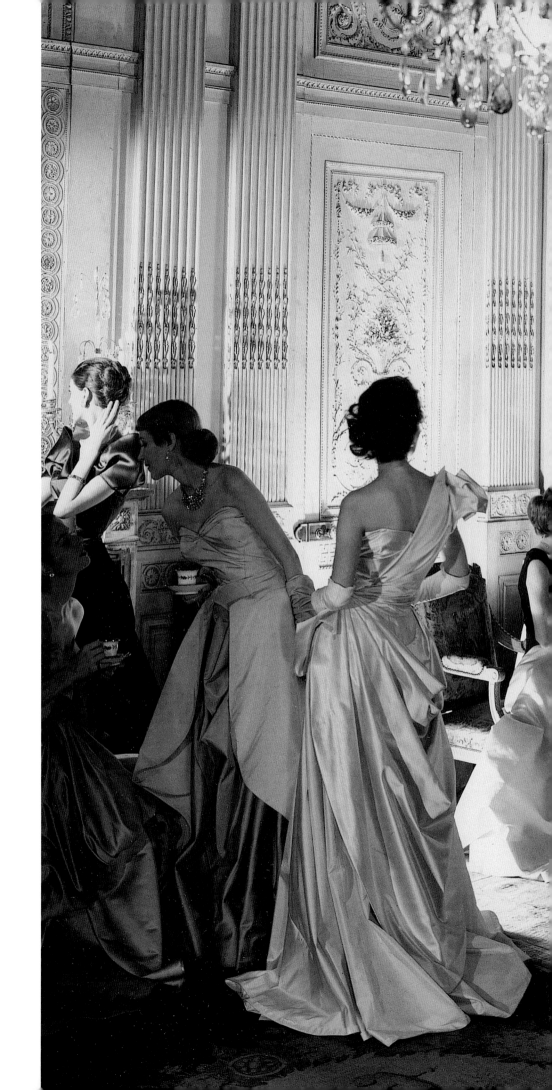

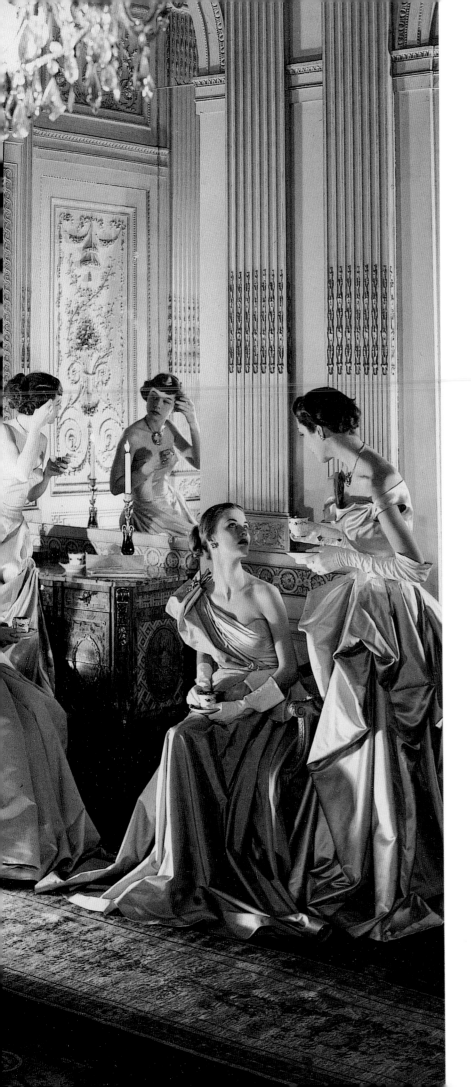

Contents

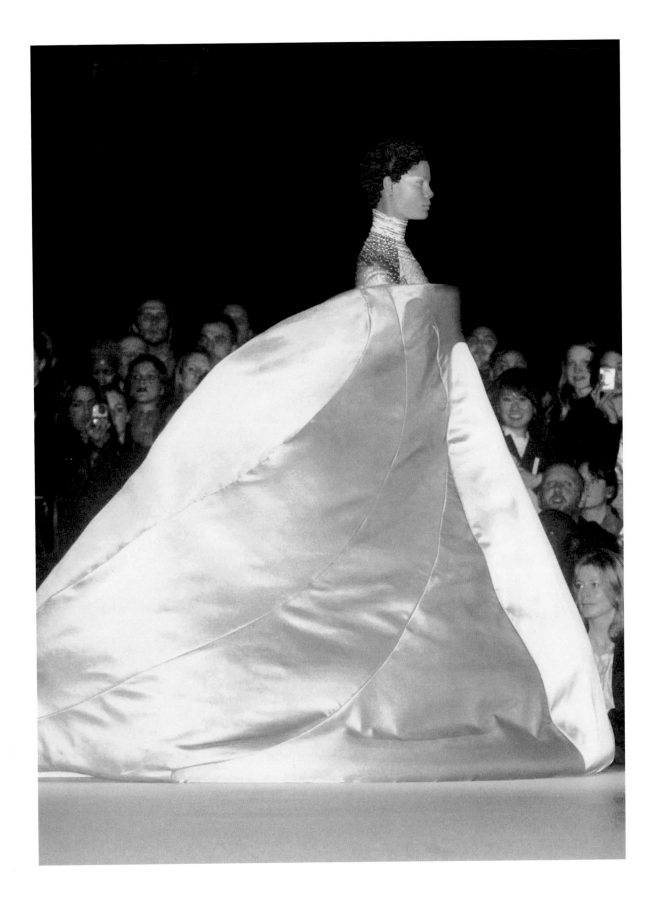

Foreword

When Madonna famously called Orlando Pita 'an angel sent from heaven to do my hair' she granted him a celestial status – the hairdresser as god, able to weave an incredible magic with the snip of his scissors and the wave of his comb.

This book recognizes, as Madonna did, the power of hair and its ability to transform. It traces how signature hairstyles, cuts, colours and moods have combined with fashion over the last hundred years to make a stamp on the times.

The way we wear our hair taps deep into the psyche. It is mood-changing, image-changing and in some cases even life-changing. Over many years working in the fashion and beauty industries, I have seen this alchemy develop time and again. Take the moment during a makeover when a woman looks into the mirror – her hair newly cut, coloured and re-styled – and sees, looking back at her, an amazing image, a person she never dreamed she could be. The same magic happens on photo shoots when the photographer has fixed the lighting, the make-up is set, the clothes chosen and the end result discussed. The creative stylist is always the last to step into this scenario – whether behind the scenes at a catwalk show, in a studio or on an exotic location. In order to transform the model he or she may need extensions, wigs, coloured highlights, rollers to curl, irons to straighten, pins to tame, fingers to plait, combs to smooth or accessories to decorate. He may be hurried by the need to catch the light or the moment. But what he does (or doesn't do) in those few minutes transforms the whole idea into a new reality. Whether pinned up in an immaculate chignon, tumbling in curls around the face, lit with sharp streaks of peroxide or aggressively gelled in tufts, the hair in question becomes a trademark, an identification of the wearer and, it goes without saying, a crucial accessory to the clothes.

Hair and Fashion rattles through the history of hair and pinpoints definitive hair moments of the twentieth century from Louise Brooks' shiny bob to Marilyn Monroe's peroxide curls; from Vidal Sassoon's geometric cuts and Andy Warhol's wigs to David Beckham's mohicans; from the skinhead to the hippie, the teddy boy to the mod, touching on beehives, fringes, mullets, dreads and extensions on the way... It shows that hair and its colour are intrinsic to both our mood and personality. 'For me,' says Donatella Versace, 'being blonde is not just having a hair colour; it is a way of being and a state of mind.' She surely proves the point that a hairstyle can turn you into an icon. In this book we have The Beatles and Beyoncé, Louise Brooks, Twiggy, Marilyn Monroe, Elizabeth Taylor, Mia Farrow, Boy George and Sarah Jessica Parker. Not to mention Madonna transformed by Orlando or Luigi Peroni or Princess Diana elevated from Sloane Princess to fashion icon by Sam McKnight.

Hair and Fashion shows us the way that fashion and hair are inextricably linked. As Orlando Pita says, 'With so little you can change yourself so much.'

Kathy Phillips
Vogue Contributing Editor and Founder of 'This Works'
2004

Our hair speaks with a voice as soft as cotton. If you listen closely – put your ear right up to it – it will tell you its secrets.[1]
Ntozake Shange 2000

Introduction

Alexandre, the renowned French hairdresser, described hairstyling as 'a desperate search for an eternal and fugitive beauty... for that which will last for only one day.'[2] It is this intangible, fleeting quality of hair that is its greatest strength. Whatever style we choose to adopt will always disappear over time – perhaps this is why the haircut has rarely been the subject of serious study and its full cultural meaning still remains to be teased out. Regarded as a fashion accessory rather

than an art form in its own right, hair still remains theoretically isolated whilst fashion is a burgeoning area of cultural studies. But hair has often led the way – for example, the 1920s bob or Eton crop, which reflected the zeitgeist at a time when women participated increasingly in cultural life and refused to accept unquestioningly the traditional roles of wife and mother. The Afro is another look that during its heyday in the early 1970s made such clear associations with race, politics and counterculture that debates were sparked in the popular press denying the usual 'invisibility' of hair and rendering catwalk fashion banal and obsolete. Thus hair is both mute and meaningful. It grows from our bodies and is inextricably linked with our psyche. The head of Medusa of Greek mythology, her hair a mass of writhing snakes, caused all who glimpsed her to turn to stone until her decapitation by the winged hero Perseus. It's an image of such deadly glamour that it has become the logo of fashion house Versace.

This book will demonstrate that throughout the last hundred years hairstyles – whether turbulent or settled, sexy or straight – have been a sign of the times and are inextricably bound with fashion. Hair *is* fashion and fashion *is* hair, and there have been key moments in the history of fashion when hair has been the focus – when photographer, model, designer and stylist have created a look of such sublimity that it has fused into our collective consciousness. The seminal haircut for Twiggy (Lesley Hornby) by Leonard Lewis of Mayfair in 1966 was such an event – it changed her image and set the scene for a new kind of fashion. As he put it, her hair 'was long and uninteresting and did nothing to show off her features. It was also in the most terrible condition, having been bleached and cured to death.'[3]

above

The 1920s bob perfectly complemented the more sportif, **modernist look of the decade** **with its sleek lines and practical functionalism.** (1930)

Justin de Villeneuve, her boyfriend at the time, described the scene: 'Lesley was there the whole day. Hair cut short, not finished so Daniel Galvin could put in highlights, then downstairs for Uncle Len to finish it off. When he'd finished a pin could have dropped and you would have heard it out in the street. Clients, models, staff cleaners, tea boys, receptionists were all speechless. It was like a magic moment in a corny movie. Leonard had created a minor miracle.'[4] Twiggy's look, a new interpretation of the 1920s Eton crop, was immortalized by photographer Barry Lategan and, on seeing the results displayed in the window of Leonard's salon, the fashion editor of the *Daily Express* Deirdre McSharry dubbed her the 'Face of 1966'. Twiggy's look, together with a mini-skirt and kinky boots, became the defining image that came to immortalize London in the 1960s. As Leonard describes it: 'Twiggy's arrival on the scene changed everything in the modelling business. Her look was a complete contrast to [Jean] Shrimpton and the other girls at the top. Her shape influenced every designer and every model from then on.'[5]

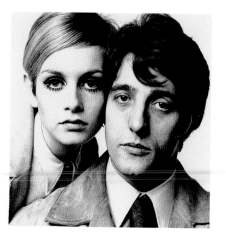

The role of the session stylist – that is, a hair stylist who works on the hair of models for photo shoots, advertising campaigns and the catwalk – has been paramount in creating these moments. The significance of the job was not really recognized until the 1960s, however, partly because for most of the time, as top model Jean Shrimpton remembers, 'models were expected to be on time with their hair properly done and their pancake make-up in place. Unlike today, there were no hairdressers and make-up artists on the sessions; it was many years later before they were hired as a matter of course for most photographic sessions.'[6] Occasionally magazines such as *Vogue* did bring in a hairdresser, but in the main they were specifically used for hair

above

Fashion model Twiggy with her manager and partner throughout the 1960s, Justin de Villeneuve. De Villeneuve originally trained **as a hairdresser with Vidal Sassoon under the pseudonym Christian Saint Forget.** (1966)

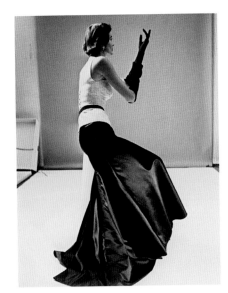

product shoots alone where, of course, the hair had to look perfect as it was the main focus of the photograph. There could be problems, however, for the stylist had to follow the dictates of the photographer. Vidal Sassoon, for instance, was employed to work on a shoot with Richard Avedon in the late 1950s and found his lesser position difficult: 'I began to work with the fairly reasonable assumption that I would do the hair, while he concentrated on taking the pictures. It did not work that way, however. He fussed around the hair constantly, asking me to change this and twist that, but never seeming quite satisfied with the result.'[7] Sassoon eventually walked out.

The poses and clothes used in fashion photographs prior to the work of New Wave photographers David Bailey, Terence Donovan and Brian Duffy in the 1960s are very formal, and on flicking through the pages of top fashion magazines *Vogue*,

above

The neat, chic haute coiffure **of the 1950s was extremely high maintenance. Hair was fixed to** **within an inch of its life to create the correct 'groomed' appearance.**

Harper's Bazaar and *Vanity Fair*, it's incredible to see how many models wear hats and gloves. Terence Donovan worked for a time as John French's assistant but was keen to break away from his elegant, but constrained style: 'We should be taking pictures where the models actually look alive. Their hair should be blowing in the wind, not jammed into some twenty guinea titfer!'[8]

It was the collaboration of Jean Shrimpton and David Bailey that created the new easy bohemian look that Donovan wanted. Shrimpton remembers: 'When I was not working for *Vogue* I had to do my own hair. Unfortunately I was never very good at it. I used to rush around London with my hair in rollers under a scarf, or try my best with the ratty hairpieces that were fashionable at the time. Not surprisingly, I wasn't doing too well until Bailey created the Jean Shrimpton look.'[9] Her hair was left down instead of dressed up and flipped up at the ends or pulled into a ponytail, a kind of unstyled style that can be seen revived in the collaboration of Kate Moss and photographer Corinne Day in the 1990s.

Hairdressers actively wanted to be part of these magical collaborations, which were becoming increasingly experimental by the 1970s. Leonard recalls: 'Whenever there was an opportunity to accompany a model to a photographic session I would grab it. I wanted to climb inside those glossy magazine pages that I had pored over so eagerly and be part of the creative process. I loved the excitement of the lights, the tripods and the tantrums. The mounting tension as the photographers disappeared under their hoods, shouting orders at the assistants.'[10] By the end of the 1980s the role of the

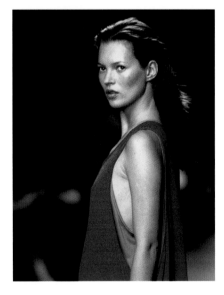

above right
David Bailey juxtaposed Jean Shrimpton's 'easy' hairstyle with seemingly 'unposed' poses to create a New Bohemian look. (1965)

below right
Kate Moss was the face of the early 1990s grunge look and her mid-length, unstyled hair became a defining trend of the 1990s.

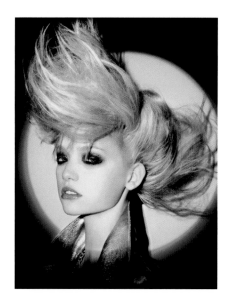

session stylist was secured and widely known. Sam McKnight, one of the most renowned, who has worked for big names in the fashion industry (including Prada, Vivienne Westwood and Gianni Versace), saw session styling 'taking off in a big way' in that decade 'because of the whole supermodel phenomenon, the whole explosion of fashion that began in the '80s.'[11] Hair was accepted as a visual art that could really contribute to the evolution of a great fashion photograph – Penelope Tree's braids for David Bailey, Leonard's work for Clive Arrowsmith, Ray Allington's fantasies for Yohji Yamamoto as photographed by Bruce Weber, and Sarah Stockbridge's peroxide blonde curls for Vivienne Westwood. 'The privileged site... on the top of our heads'[12] as hair historian Stephen Zdatny calls it, together with clothes, make-up, model and pose, now make up the total fashion look, in a symbiotic relationship of complex creativity.

above

As most agencies require their models to have mid-length hair, innovative styling rather than cutting techniques are the norm in high fashion. On this Vogue **shoot, Sam McKnight used weaves to give model Gemma Ward's hair extra body.** (2004)

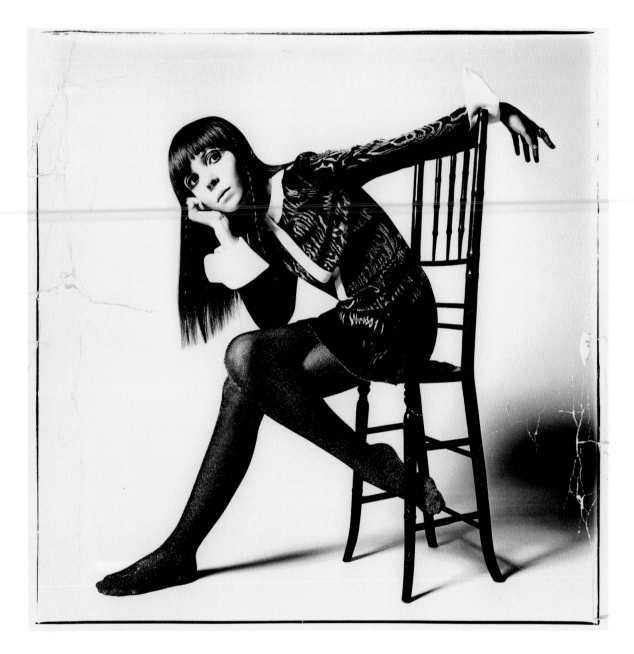

above

**Penelope Tree in a velvet tunic
and braided hair photographed by
David Bailey. In the 1960s Bailey's
'realist' fashion photographs were**

**superseded by a more formal,
studio-based approach as he
photographed the couture
collections for** Vogue. (1967)

Did I see you in my dreams, my love, because you long all day for me, your thoughts dishevelled like your morning hair [13]
Traditional Japanese haiku

chapter one: Long

Long hair makes the head erotic, a provocative body part of such unrestrained sexuality that in some cultures it has to be kept quite literally under wraps. The Jewish *sheitl*, for instance, is worn to shield the potentially carnal hair from the wolfish gaze of all men save the wearer's husband, thus protecting the fabric of Jewish society as decreed in the Talmud. In the nineteenth century the only European man permitted to see a woman with her hair unleashed in its natural state was her husband.

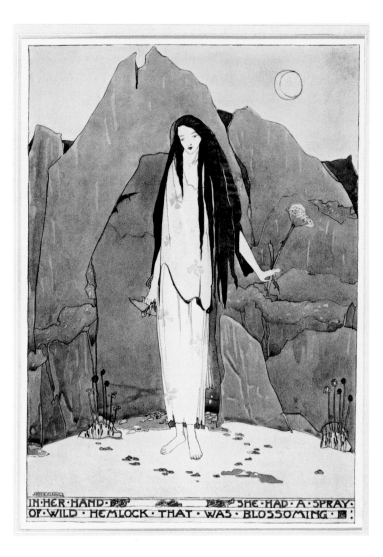

IN·HER·HAND·
OF·WILD·HEMLOCK·THAT·WAS·BLOSSOMING·
SHE·HAD·A·SPRAY·

right

**In many cultures women grow
their hair as long as possible
as it is considered the epitome
of female beauty.** (1915)

This fused an intense relationship between hair and intimacy
that reoccurs in Indian culture, where the untying of the knot of
hair is an action immediately taken before releasing the knot that
secures the sari. Long hair has always been associated with
femininity, used as both a sexual lure and a status symbol,
although at various points in history men have also sported
long locks. The unbridled strength of the hyper-masculine
Samson stemmed from his luxuriant hair, and when sheared by
Delilah he lost his patriarchal power – the ultimate symbolic
castration. Those who abstain from the erotic in favour of the
ascetic, such as eunuchs, monks and nuns, renounce hair in
favour of a more spiritual crop – Buddhist monks and nuns
shave their heads to relieve themselves of carnality as they give
themselves up to Buddha, and move from the heat of desire to

the cool calmness of chastity. In Buddhist writing men seeking nirvana are expressly warned that they could become ensnared in earthly desires by the physical attributes of womanhood: 'Hair fragrant with the scent of jasmine or sandalwood and soft to the touch forms part of this physical attraction, which binds men and women to one another and perpetuates their bondage in a world set ablaze in a fire of passion' – as religious historian Karen Lang puts it, adding 'thus to escape this all-consuming fire, monks must shave their heads, put on identical shapeless robes, and then begin the process of personal transformation that culminates in the tranquil, deathless state of nirvana.'[14] The femme fatale of popular mythology, however, uses her luxuriant curls to seduce and bewitch men, for loose hair signifies a loose woman of few morals who shares her intimacies easily. Rapunzel let down her hair to allow her lover to climb her tower rather than as a means to escape, and the Lorelei lured boatmen on the Rhine to their death by singing mournfully whilst combing out hair of liquid gold. Lilith the night demon proves irresistible to men and, as Dante Gabriel Rossetti wrote in his poem of 1867, her hair is deadly:

above left
The traditional relationship between long hair and virility is visually expressed in the biblical character of Samson, whose strength emanated from his long curls.

above right
'Rapunzel, Rapunzel, let down your golden hair.' For women, long hair has traditionally symbolized feminine beauty, and to let down one's hair in front of a man was an invitation to intimacy. (1914)

above left

In the mid-nineteenth century, Empress Eugenie of France was one of the leaders of fashion, dressed by Charles Frederick Worth, a key couturier of the time.

above right

Hair and fashion perfectly complemented each other in the late nineteenth century. Both hair and fashion were extravagantly decorative, impractical to wear and a mark of social status.

(1875)

'Lo! As that youth's eyes burned at thine, so went
Thy spell through him, and left his straight neck bent,
And round his heart one strangling golden hair.'

In Western culture it was in the nineteenth century that the gendered split in hair truly began, mirroring the sexual demarcations laid out in fashionable dress. Extravagant hairstyles that were once favoured by both sexes now became the preserve of women who needed the ministrations of maids and hairdressers to tease and tuck their hair up into ornate shapes, transforming the raw into the cooked, dishevelled sexuality into domestic refinement. Young girls were exhorted to brush their hair a hundred times a night to encourage growth and thus fit the fashionable ideal of the day that demanded hair so long one could sit on it. As one favoured saying put it: 'With a veil of long hair covering her shoulders, a plain woman may look like a goddess; without hair; she is not even a woman.' The ornament

of hair was reflected in fashion: cage crinolines, sloping shoulders and delicate waists made women into ornamental creatures bedecked in richly coloured and decorative fabrics covered in lace, frills and embroidery. Couturiers Charles Frederick Worth, Mesdames Palmyre, Victorine and Vignon created extravagant gowns of tulle and duchesse satin to be worn by prestigious customers such as Empress Eugenie of France.

This look had its pitfalls, however. In particular the cleaning of long hair was difficult in the days before hot running water and soapless shampoo. French aristocrat Comtesse de Pange admitted that 'at seventeen, I had very long hair which, when loosened, wrapped around me like a mantle. But these beautiful tresses were never washed. They were stiff and filthy. The word shampoo was ignored. From time to time they rubbed my hair with quinine water.'[15] Washing a head of heavy hair was considered a peculiar act. Antoine de Paris recalled going to the residence of the Comtesse de Farge in 1904 to dress her hair for a special occasion and being flabbergasted by the state of it, 'so greasy', he remembered, 'that one could have made a bad soup from it'. Antoine suggested strongly that he wash her hair before dressing it. The Comtesse was aghast. 'No,' she replied. 'Never. understand that I *never* shampoo. *J'ai horreur de ça!*' Antoine shot back, 'The truth, madame, is that I would not touch your hair in such a filthy state,' and he turned to leave, accompanied by a hail of insults 'that would have done credit to a fishmonger'.[16] The idea of a swain running his fingers through the hair of his beloved was a non-starter, as the quality of women's hair prevented such manifestations of love. In 1887 writer Octave Uzanne complained of hair that was 'uncombed, fluttering in dismay, mixed with shams of every sort, burnt by acid, roasted by iron, dried up by ammonia; this dead hair, which fell in curls or frisettes under the cap, was indeed the most disagreeable thing.'[17] To achieve the upswept and curled dos of the day required backcombing and marcel waving, but little was understood of the properties of hair or hair health – a

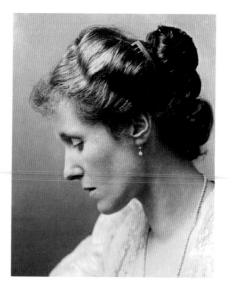

above

A typically ornate Edwardian hairstyle in a popular Grecian revival style. Postiche **or false pads of hair were used to supplement the natural.** (1902)

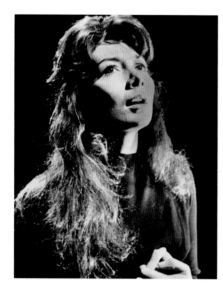 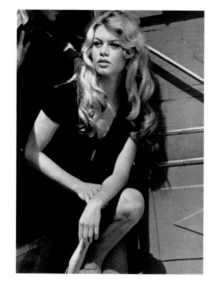

above left
Singer Juliette Greco rose to fame as the face of France's New Bohemianism in the 1950s. Her long unruly hair set a new style for European teenagers. (1957)

above right
Brigitte Bardot's image in the late 1950s as a sensual, sunkissed starlet fresh from the beaches of St Tropez was expressed in her erotic film roles and tousled and backcombed long blonde hair. (1957)

opposite
The Rolling Stones with model Patti Boyd in 1964. The Stones' long, seemingly unstyled hair gave them an edgy reputation, although in fact it was carefully managed by hairdresser Harold Leyton.

concern that had become an international phenomenon of branded business by the twenty-first century. The bob supplanted the long-haired look in the 1920s but by the late 1950s long hair was back with beatnik girl Juliette Greco and sex siren Brigitte Bardot. Their long tousled locks were in direct antithesis to the hairsprayed helmets of their contemporaries, and ushered in a look that was youthful and spoke of an earthy sensuality, preparing the way for the new sexual morality of the hippie generation.

For men, however, long hair has more complicated cultural meanings. Homeric gods have flowing hair; Thor the Norse god caused thunder by shaking his shaggy hair and beard, but for the more prosaic mortal, long hair is considered an expression of vanity, a trait culturally appropriate for women who for most of their history have had to depend on their looks for their social success and advancement. In 1859 a book on etiquette, *The Habits of Good Society*, stated that long hair for men was 'inconvenient and a temptation to vanity, while its arrangement would demand an amount of time and attention which is unworthy of a man'.[18] In 1964 Mick Jagger of the Rolling Stones

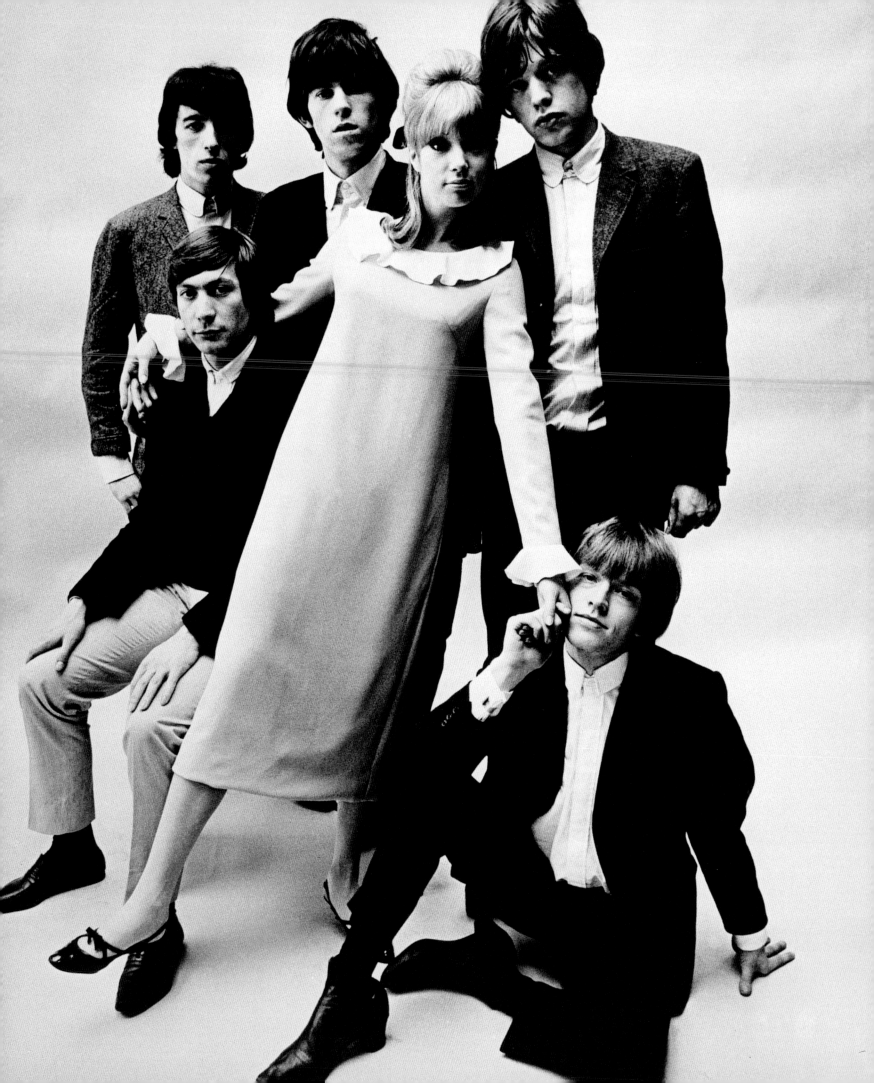

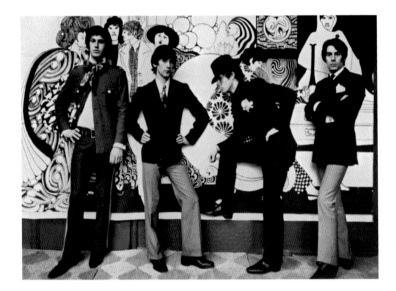

above right

In the 1960s young men began to grow their hair to collar-length for the first time since the nineteenth century following new fashions that celebrated the peacock male. (1966)

made the same point, remarking that 'Hair is a sexual, personally vain thing. Men have always been taught that being masculine means looking clean, cropped and ugly.'[19] Jagger's comment implies that when intimations of vanity begin to creep into prevailing definitions of masculinity, many take this to signify that the boundaries between male and female are being breached and hint at a cultural destruction to come. Writer Bruce Jay Friedman was another commentator in the 1960s who tried to explain the moral panic surrounding men with long hair: 'I guess that what frightens them is that if the boys wear their hair long, why then the boys are going to look like girls, and the lines between the sexes are going to get blurrier then ever. This can be frightening, and what better solution than to chop off a little hair, so that the sex division can be all tidy again.'[20]

Men who grow their hair long are brave to challenge such cultural taboos – perhaps that's why the long-haired man is often regarded as a romantic outlaw and renegade, someone who lives on the margins of society. In historical terms this notion has a long lineage. Romans regarded long hair as a mark of barbarian culture and in late imperial China any amount

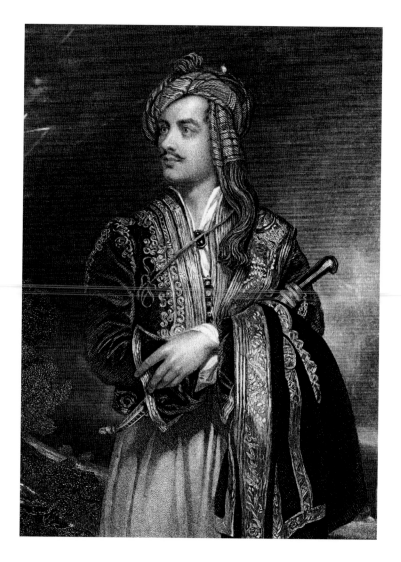

Lord Byron, one of the Romantic poets, cultivated a less formal, more exotic image of masculinity in the early nineteenth century. This included growing his hair to show his disdain for hidebound tradition. (1810)

of hair, including the beard, was seen as transformative, a step away from civilization into the wilds of nature. As anthropologist Frank Dikotter puts it, 'the hairy man was located beyond the limits of the cultivated field, in the wilderness, the mountains, and the forests, the border of human society, he hovered on the edge of bestiality.'[21] In the early nineteenth century Romantic poets such as Byron and Chatterton showed their allegiance to emotion rather than science by their untamed hair, eschewing the powdered wigs of polite society. Thus the idea of the long-haired man as rebel has been used as a blueprint for those who want to rail against the constraints of straight society, such as the beatniks of the 1950s and the hippies of the 1960s, who set themselves apart from the norms of mainstream fashion. Writer David Horowitz

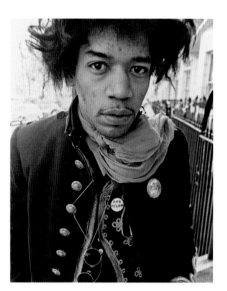 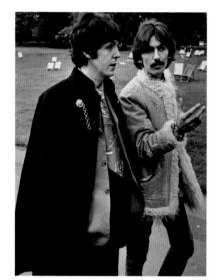

above left

Jimi Hendrix's mix of untamed Afro hair and hippie clothing, in particular his espousal of vintage military jackets, was romantic and fashionable yet subversive at a time of social upheaval and political unrest. (1967)

above right

Paul McCartney and George Harrison of the Beatles in 1967, with hair that at the time would have been considered extraordinarily long for young men. Their dress is an eclectic mix of vintage, high fashion and pure hippie.

opposite

By the early 1970s the long-haired look for men had been incorporated into fashion and was no longer a symbol of countercultural rebellion. (1972)

remembers that 'people looked different. Peace symbols and crystal pendants had replaced crucifixes and Stars of David as emblems of religious conviction. Clothes were tie-dyed and bucolic, colours psychedelic, and hair long. Women were going bra-less... I felt: a new world is possible.'[22]

The first long-haired men in the 1960s suffered much abuse and ridicule. In defence of long hair (and as an astute marketing ploy) David Bowie, with his manager Ralph Horton, formed the Society for the Prevention of Cruelty to Long-haired Men in 1964. Interviewed on TV at the age of 17, Bowie complained: 'For years we've had comments like "Darling" and "Can I carry your handbag?" thrown at us, and I think it has to stop.'[23] By the end of the '60s long hair was symbolic of revolution, a form of public liberation like freedom of speech, and when co-opted by fashion was sported by pop and rock stars such as the Beatles and the Rolling Stones as well as political agitators. It was adopted by the growing number of people demonstrating against America's war in Vietnam, and exemplified in the figures of Peter Fonda and Dennis Hopper in the film *Easy Rider* of 1969. Crosby, Stills and Nash even eulogized the hippie look in the

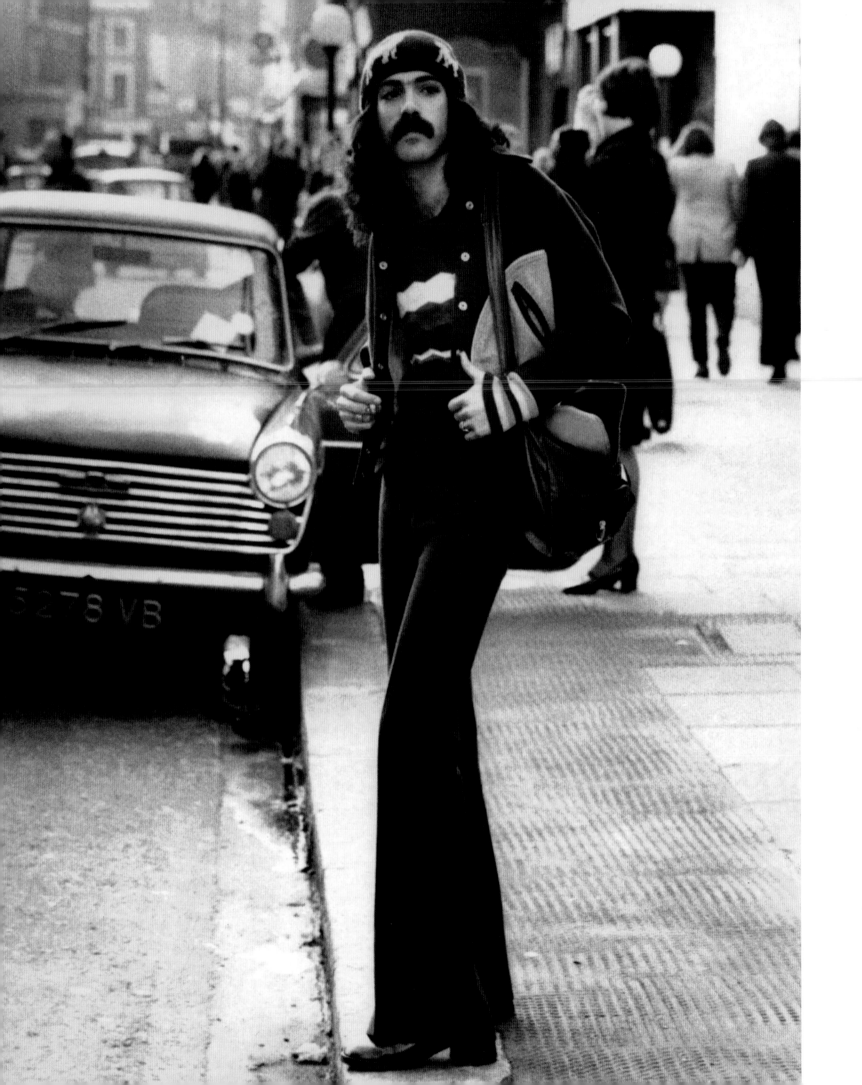

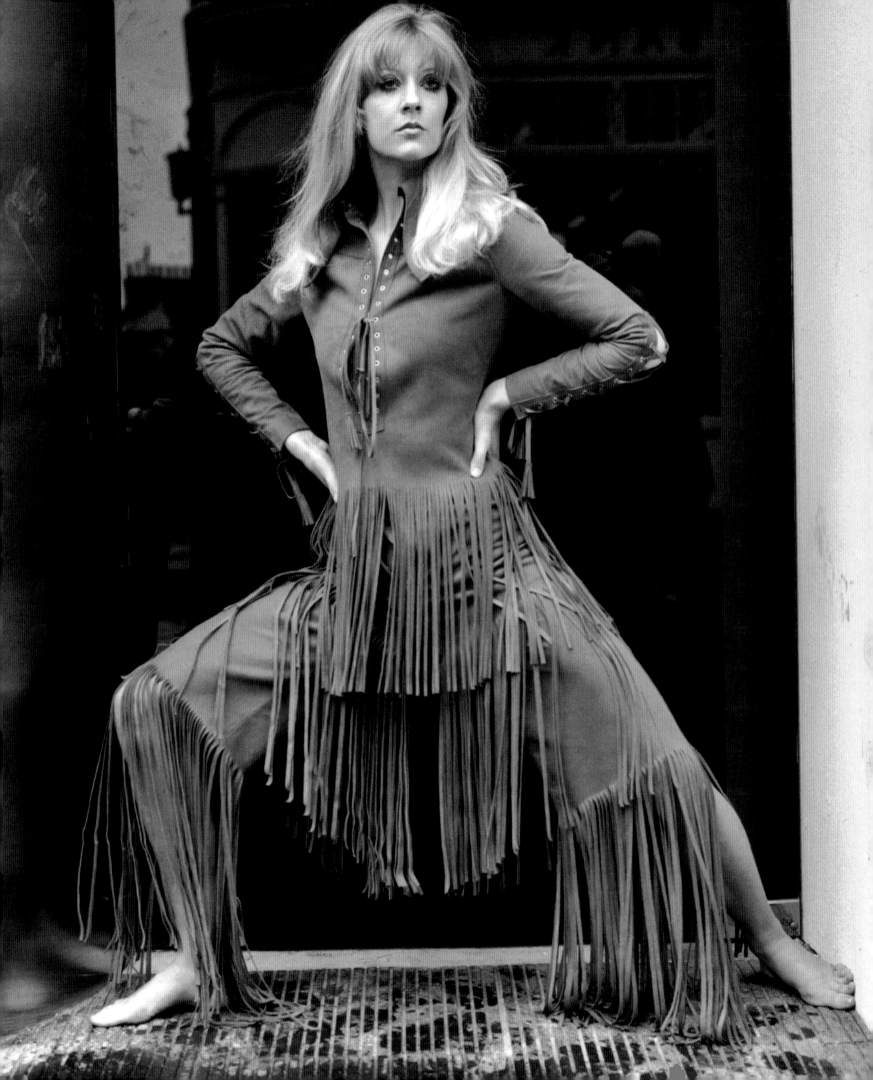

 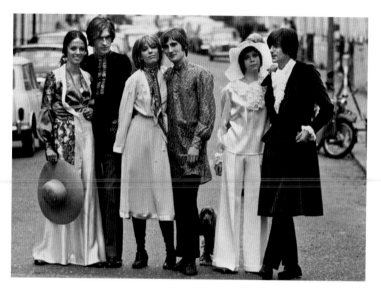

song *Almost Cut My Hair*. By the end of the 1960s a campaign united straight American society with billboards exhorting young men to 'BEAUTIFY AMERICA: get a haircut', but just a few years later most men on both sides of the Atlantic had hair reaching at least to their collar, and fashion designers had picked up on the look. In Britain, Ossie Clark, Bill Gibb, Zandra Rhodes and Biba played with the hippie look on the catwalk with a kaleidoscope of print, texture and layering that incorporated a romantic ensemble of eclectic sources that was pure Haight-Ashbury, ranging from American Indian suede, gypsy-fringed shawls and embroidered kaftans to velvet Edwardian-inspired frock coats worn with crotch-hugging jeans and ruffled shirts first seen on Jimi Hendrix but incorporated into menswear by designers such as Yves Saint-Laurent. All the English pop aristocracy and Beautiful People wore Ossie Clark: the Rolling Stones, Julie Christie, and Marianne Faithfull, who 'bought a suede suit trimmed with python and a fluted peplum and never asked the price.'[24]

The association of long hair and rock music has continued right up to the 2000s. Heavy metal music has been a last bastion of the long-haired guitarist who plays deafening solos whilst

above left

Marianne Faithfull, singer and model, was famous in the 1960s as the partner of Mick Jagger. Her mid-length cut with flipped ends was a typical teenage style of the mid-1960s. (1964)

above right

A mix of romantic late '60s looks which use historical style and long layered hair for both men and women to create a softer version of hippie styles. (1968)

opposite

Fashion designer Ossie Clark took the rebellious image of hippie counterculture and incorporated key elements such as American Indian fringing into catwalk fashion. (1969)

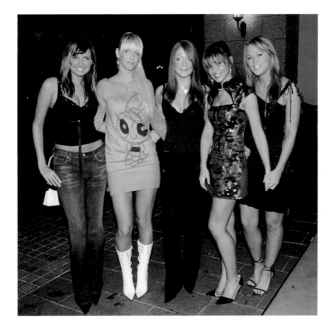

above

Pop group Girls Aloud display a mainstream look that graced every high street in the early 2000s: a mix of jeans, high heels, '80s revival fashion and long, ironed hair. (2004)

thrashing a wild mane and wearing skintight lycra – an image which has been appropriated with irony by the cod-rock band the Darkness in 2004. For women, a mainstream look of long, straight ironed hair with an almost silicone sheen has been popularized in the last few years by pop bands such as Atomic Kitten and Girls Aloud, models Caprice and Naomi Campbell and actress Jennifer Aniston. Worn with Maharishi cargo pants or '80s-inspired Top Shop minis with batwing sleeves and a pair of Jimmy Choos, this look has become ubiquitous on the streets of cities across the globe. Long hair thus has many meanings. For women, it's a traditional mark of beauty, for men it veers between an expression of hyper-masculine strength and the effete nature of fashion. Women of today want copious amounts of hair on their head, aiming for crowning glories that make them queens, but these days are allowed almost none on their bodies – unlike men, whose virility is displayed in hairiness. Closer to nature than culture, long hair is bound to sex.

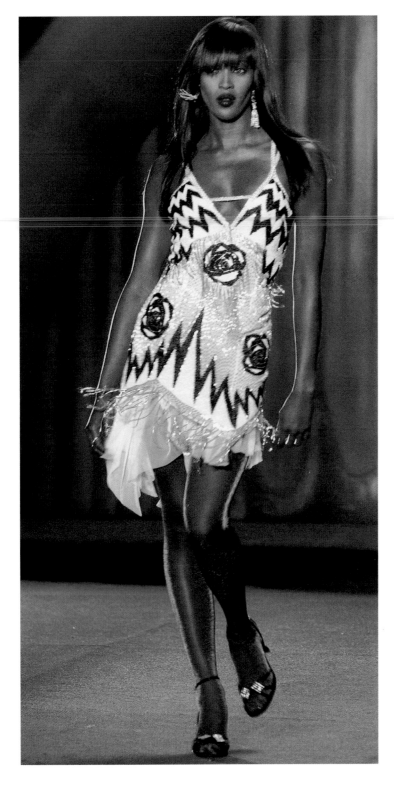

above

**Glamour model Caprice displays
the hairstyle that has dominated
women's hairdressing over the
last ten years – long and ironed
to create a straightened shiny
surface.** (2001)

left

**Naomi Campbell was one of the
first truly global black supermodels
in the 1980s and 1990s, known
for her athletic body, diva
reputation and waist-length
hair extensions.** (2003)

It was a blonde. A blonde to make a bishop kick a hole in a stained glass window. [25]
Raymond Chandler

chapter two: Colour

The celebrated heroine of children's literature, Anne of L.M. Montgomery's *Anne of Green Gables* (1908) bemoaned her red plaits, the source of amusement for others and much anguish to herself. In the opening scene she 'twitched one of her long glossy braids over her thin shoulder.... and let the braid drop back with a sigh that seemed to come from her very toes and to exhale forth all the sorrows of the ages. "Yes, it's red," she said resignedly. "Now you see why I can't be

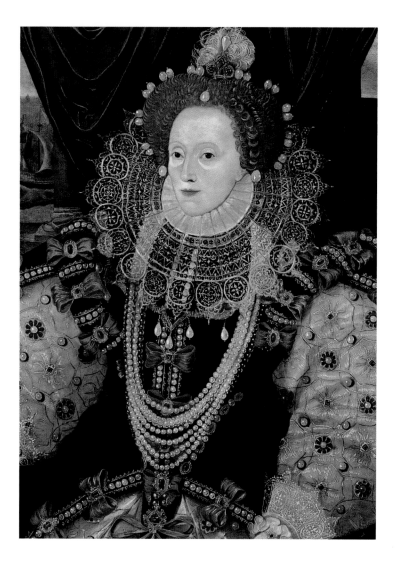

Queen Elizabeth I reigned from 1558 to 1603 and kept tight control over the dissemination of her image. A natural blonde, in portraits she was often depicted in muted colours to offset her false red-gold hair.

perfectly happy. Nobody could who has red hair."[26] This has not always been the case, however, and the apocryphal story of the origins of red hair is one of the most romantic. According to legend, Prince Idon of Mu fled his land after intimations that it was to be destroyed by a natural catastrophe, and arrived at Atlantis in time for the sunset. Moved to tears by its sublimity he wished that its beautiful red tones could be saved for posterity. In an instant his hair was changed to red and every succeeding generation of redheads was reminded of that first spell-binding sunset.

Throughout history those not content with their natural hair colour have been able to enhance its beauty with artificial dyes and tints. In the twentieth century, when most of the most

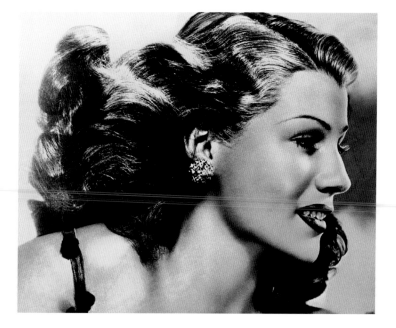 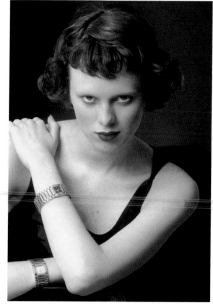

innovative developments took place, new colours came courtesy of Eugene Schueller, whose dyes of 1909 were the first properly marketed range offered to the public under the name 'L'Oréal'. Schueller was, according to hair historian Stephen Zdatny, 'without question, from a commercial point of view, the most important single figure in the hairdressing profession up to the outbreak of the Second World War.'[27] The L'Oréal colours became associated with a new culture of consumption that revolved around appearance, with make-up, hair and fashion as its key. Women were becoming more experimental with hair cutting and colouring, and hairdressing and its associated products burgeoned into the massive industry we know today.

Actresses Ginger Rogers, Rita Hayworth and Lucille Ball, along with catwalk models Linda Evangelista and Karen Elson, have made careers out of changing their hair colour to red. The strong yet fiery natures of Henry VIII and Elizabeth I are read from their hair colour by succeeding audiences, and singers Tori Amos and Shirley Manson of Garbage display a unique countercultural chic with their flaming locks. Response to hair colour, however, is fickle and depends on prevailing cultural

above left

Rita Hayworth was famed for her red hair and role as femme fatale in the film Gilda **(1946). Her husband Orson Welles ordered her to cut and dye her hair blonde for his film** The Lady from Shanghai **(1947), but her career faltered and never really recovered.** (c.1950)

above right

Model Karen Elson in her trademark bright red bob. She was given an edgier image by session stylist Guido Palau in the 1990s who cropped her hair into an asymmetrical 'Joan of Arc' cut. (1997)

above

Erwin Blumenfeld incorporated a populist Surrealism into his fashion imagery, here juxtaposing a natural blonde with the artificial beauty of a mannequin. (1945)

opposite

Jean Harlow, star of Platinum Blonde **(1931), in a clinging bias-cut gown in white to match her magnesium blonde bob. Her early death from renal failure was falsely attributed to her use of the bleach bottle.** (1936)

attitudes, modes and manners of behaviour. For instance, the morality of dyeing one's hair has been much debated, particularly over the last century. Blondeness in particular is considered the height of beauty if natural – princesses in fairy-tales have cascades of long, golden hair – but if the colour is self-administered, the cultural associations can be overwhelmingly negative. Dubbing someone a 'bottle blonde' in the 1950s, for instance, was a withering insult summoning up an image that was cheap and nasty, or at the very least a bit empty-headed.

Hydrogen peroxide, the first chemical means of lightening hair, was invented by Thenard in 1818, but its cosmetic potential was not realized until a century later and even then was not really approved of. Few were prepared to admit to using it, as the taboo against dyeing the hair was so strong. Beauty journalist Isabel Mallow, who wrote regularly for Women's Home Journal, declared: 'It goes without saying that a well-bred woman does not dye her hair. If in some moment of, I was going to say, temporary insanity, she should be induced to do so, although it would be mortifying and she would have to permit herself to

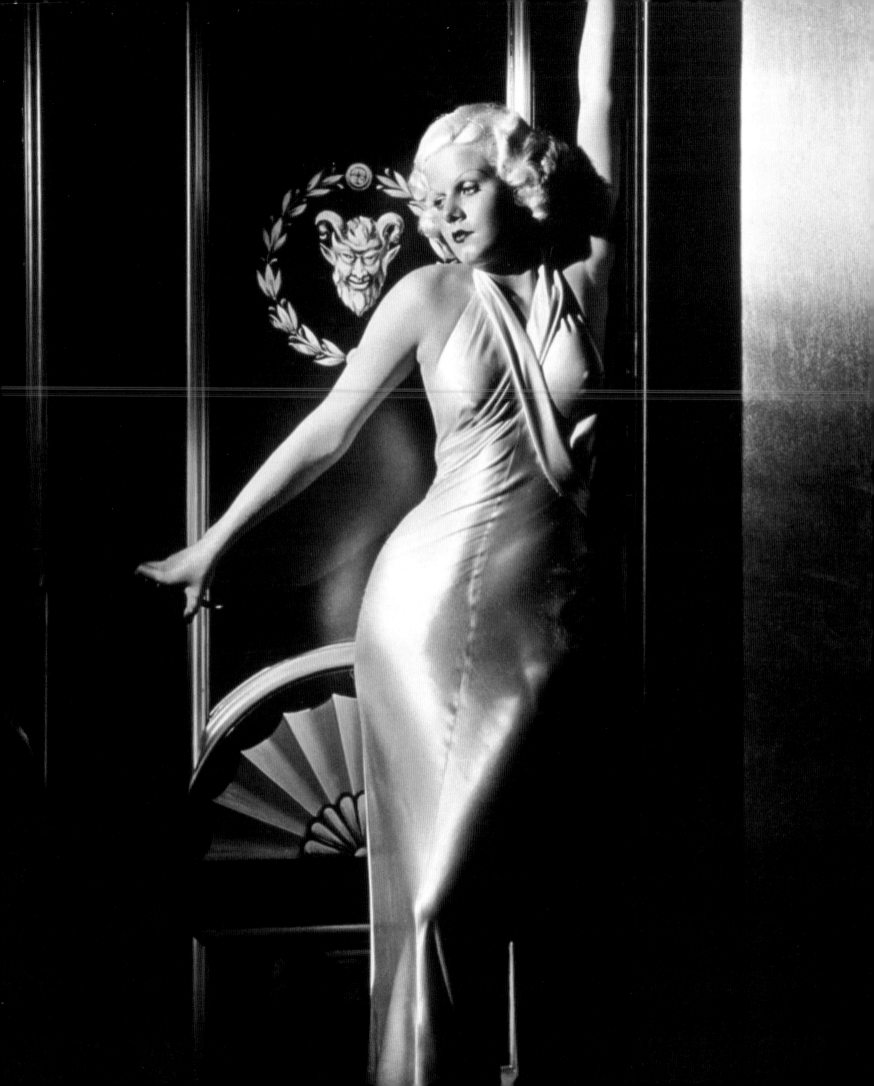

above left

Actress Marilyn Monroe reinvented herself in the 1950s by bleaching her mousy brown hair a golden blonde hair offset by red lipstick and her hourglass figure. (1952)

above right

Kim Novak was one of a string of icy blonde actresses used by Alfred Hitchcock in the 1950s; others included Grace Kelly and Tippi Hedren. He famously cast them as victims in scenes of tension and terror, enjoying watching their cool images crumble under pressure. (1954)

look like a striped zebra for a short time, still it would be wisest to face the situation and allow the hair to grow back to its natural colour.'[28]

This all changed by the 1930s. Blondeness reached its height of popularity when glamorous, high-status screen star Jean Harlow appeared in *Platinum Blonde* (1931) with her head of white hair exaggerated by magnesium lighting and black-and-white film. Draped across Art Deco sets, her hair alight as if it were phosphorescent, whiter than white, Harlow wore dresses so tight she had to eschew underwear and dye her pubic hair to match her curled bleached bob. Her brilliant white, cire-satin, bias-cut evening gowns, originally invented by Madeleine Vionnet in Paris, were copied by the high street as Hollywood became the source of mainstream fashions for women. But the taboo remained and even Jean Harlow, so obviously artificial, was not prepared to confess all to her fans, admitting only that she put 'a little blueing' in the water when she washed her hair.

By the 1950s blondeness was not merely a look, it was a whole psychology – as identified in one of the most successful slogans

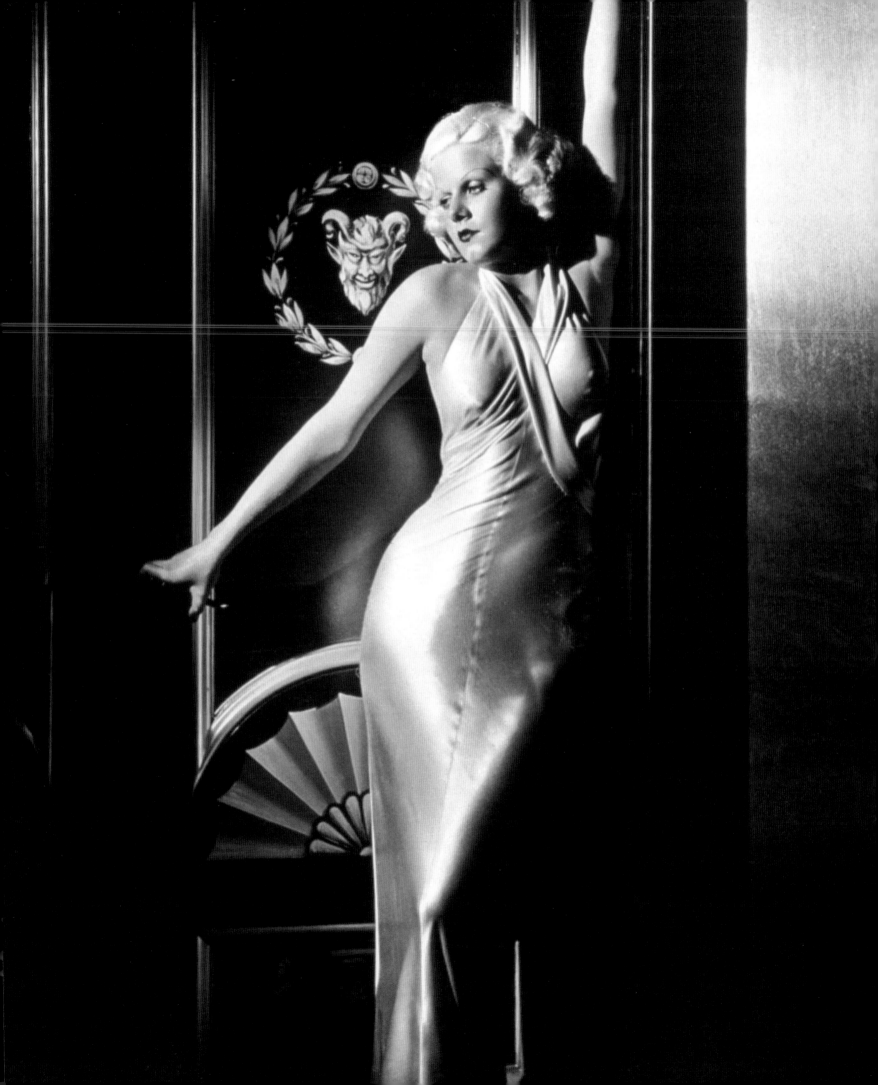

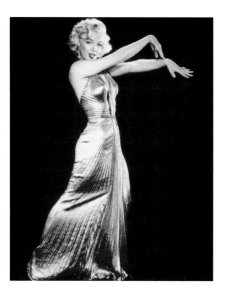

above left

**Actress Marilyn Monroe reinvented
herself in the 1950s by bleaching
her mousy brown hair a golden
blonde hair offset by red lipstick
and her hourglass figure.** (1952)

above right

**Kim Novak was one of a string
of icy blonde actresses used by
Alfred Hitchcock in the 1950s;
others included Grace Kelly and
Tippi Hedren. He famously cast
them as victims in scenes of
tension and terror, enjoying
watching their cool images
crumble under pressure.** (1954)

look like a striped zebra for a short time, still it would be wisest
to face the situation and allow the hair to grow back to its
natural colour.'[28]

This all changed by the 1930s. Blondeness reached its height of
popularity when glamorous, high-status screen star Jean Harlow
appeared in *Platinum Blonde* (1931) with her head of white hair
exaggerated by magnesium lighting and black-and-white film.
Draped across Art Deco sets, her hair alight as if it were
phosphorescent, whiter than white, Harlow wore dresses so
tight she had to eschew underwear and dye her pubic hair to
match her curled bleached bob. Her brilliant white, cire-satin,
bias-cut evening gowns, originally invented by Madeleine
Vionnet in Paris, were copied by the high street as Hollywood
became the source of mainstream fashions for women. But the
taboo remained and even Jean Harlow, so obviously artificial,
was not prepared to confess all to her fans, admitting only that
she put 'a little blueing' in the water when she washed her hair.

By the 1950s blondeness was not merely a look, it was a whole
psychology – as identified in one of the most successful slogans

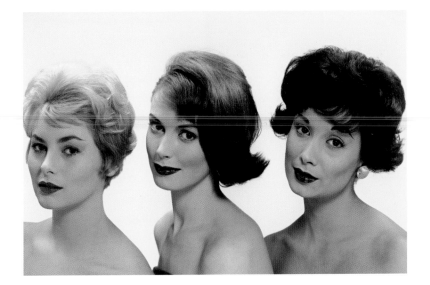

in the history of advertising: 'If I have one life, let me live it as a blonde' (for the Clairol home-dyeing kit). Blonde role models such as Marilyn Monroe, Kim Novak, Grace Kelly and Jayne Mansfield fuelled the fantasy of cool ice-maiden in Claire McCardell (regarded as 'the mother of modernism' in American fashion), or sex kitten in pink fluffy mules, leopardskin capri pants and a figure-hugging sweater. Colourist Ron Levin was one of the first to transform Marilyn Monroe's hair from dirty blonde to dazzling platinum while he was working in a tiny suburban salon called 'Louis and Simone'. The owner asked if he'd like to 'go in the back and do Marilyn Monroe's hair and there was Marilyn sitting under the dryer with her feet up on four cartons of clean towels, her glass-heeled clear plastic mules kicked off, her Borgana fake fur discarded, in a black, very fifties polo-neck sweater and turquoise torador pants. As you can imagine I was terrified.'[29]

By the 1960s colours were running riot on the heads of both men and women. *Cosmopolitan* magazine commented: 'The day of the mousy blonde has passed, as has the year of the platinum blonde, the carrot-topped redhead, the shoe-polish

above

After the restrictions of wartime rationing, women embraced fashion in the 1950s, experimenting with a variety of cuts, perms and, especially, colours. (1957)

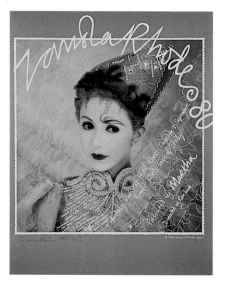

British designer Zandra Rhodes, famed for her luscious use of print and colour, collaborated with hairdresser Trevor Sorbie to create intensely feminine, eye-catching catwalk looks.

brunette. Modern women's hair has turned Just Peachy, Copper Blaze, White-Minx, Chocolate Kiss, Fuschia, Honey Doux, Bordeaux, Fury, Frivolous Fawn or even Tickled Pink. If you're ever wondering what happened to your dear old gray-haired granny, she turned Night Silver, True Steel, Silver Blue, Mink or Smoky Pearl.'[30] Even in the early 1970s, when radical feminism was at its height in the US and women were being told to turn their backs on fashion and beauty rituals, they continued to colour their hair. In 1973 L'Oréal's slogan for 'Preference' hair colour read 'Because I'm worth it' – a powerful and redemptive message for women who found the possibilities of re-invention that fashion offered extremely compelling. It became something of a cliché that a recently divorced woman in the 1970s went blonde to celebrate her newly single status. A few brave men reached for the bottle too – artist David Hockney, actor Peter O'Toole as Lawrence of Arabia, fashion designer Jean-Paul Gaultier, singers Sting, Rod Stewart and Billy Idol and of course Brad Pitt.

Barriers were being broken down again when, in the late 1960s, colourist Daniel Galvin began experimenting using nylon and poster dyes for the fashion designer Zandra Rhodes whilst working for hairdresser Leonard Lewis of Mayfair. He recalls: 'She had first come to us because she wanted to bleach her naturally black hair and dye it green. Her designs were just starting to get her noticed by the media and the public. Being a textile designer by training Zandra couldn't see why you couldn't colour hair just like material. "Have you ever thought of using the dyes I use for my silk prints?", she asked. Daniel confessed he hadn't, and she sent some samples over for him. The colours completely knocked us out. They were so different and so vibrant. We got in touch with the chemist who was formulating products for us, to find a way of turning the dyes from the fine powders which Zandra used for her silks to some sort of emulsifying wax.'[31] The colours were used not only by Zandra Rhodes herself but also to dye wigs used in the catwalk shows

**Silent screen star Theda Bara
was one of a breed of women
dubbed 'vamps' (short for
'vampire') in the early 1920s.
Their hypnotic dark looks lured
and ensnared men.**

she created with the help of Trevor Sorbie, and in 1967 the
Italian company Rembow launched Crazy Colours onto the retail
market. Less than 10 years later, punk rockers had subverted this
catwalk look, displaying their black roots with pride and creating
art out of ugliness with their parade of peacock colours.

The meanings of black hair have also shifted over time. Hair
black as a raven's wing set against a porcelain pale face
connoted a doll-like beauty in the nineteenth century, but by the
1920s dyed black hair signalled 'vamp' and was popularized by
Hollywood stars Pola Negri and Theda Bara, and 'It girl' Clara
Bow. These vampish associations continued throughout the
post-war years with stars such as Elizabeth Taylor as the
man-eating Cleopatra in the 1959 film (a character on celluloid

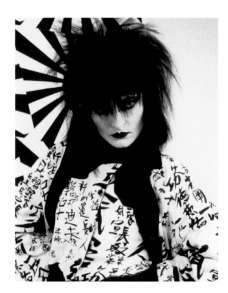

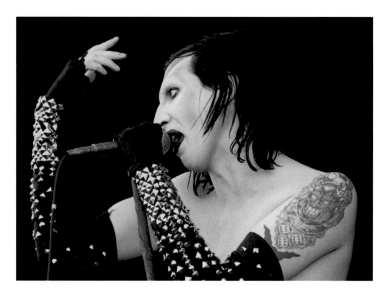

above left

High priestess of Goth, Siouxsie Sioux was one of the original Bromley contingent – the first British punks. Her huge mass of dyed black backcombed hair became an iconic twentieth-century cut. (1982)

above right

Marilyn Manson continues the Gothic trend today, blending glam rock, Nu Metal and Bowie androgony into a mix that is emulated by tribes of teenagers, but has inspired a moral backlash in the US. (2002)

opposite

Elizabeth Taylor in an iconic still from Cat on a Hot Tin Roof **(1958). With her satin slip, violet eyes and jet black bouffant, she was in complete contrast to the blonde bombshell looks of Monroe and Mansfield.**

who appeared to mirror her own chequered love life), Cher's waist-length dark tresses and the Goth subculture of the early 1980s, which lauded a death-white complexion set against a jet black mop of back-combed hair. Singer Siouxsie Sioux, described as a 'tarantula on stilts', invented this look with the help of hairdresser Roger Taylor: 'I knew I wanted something different, it was just a case of trial and error really. Someone told me about crimpers and after using them a few times I realized what you could actually do with them. One day I just started hacking and came up with the idea for the look – I wanted a haircut that was gravity-defying... I've always tried to be the antithesis of the curvy, tanned, blonde bombshell.'[32] Robert Smith of The Cure wore the male equivalent with grotesquely smudged red lipstick – a death's-head image that was continued in the 2000s with glam rock revivalist Marilyn Manson, whose face has launched an army of teenage lookalikes in the best traditions of rock and roll.

Colour has transforming effects. It can be used as a signalling device, a move towards independence, for some providing a visual break from an unsuccessful relationship, or for others a

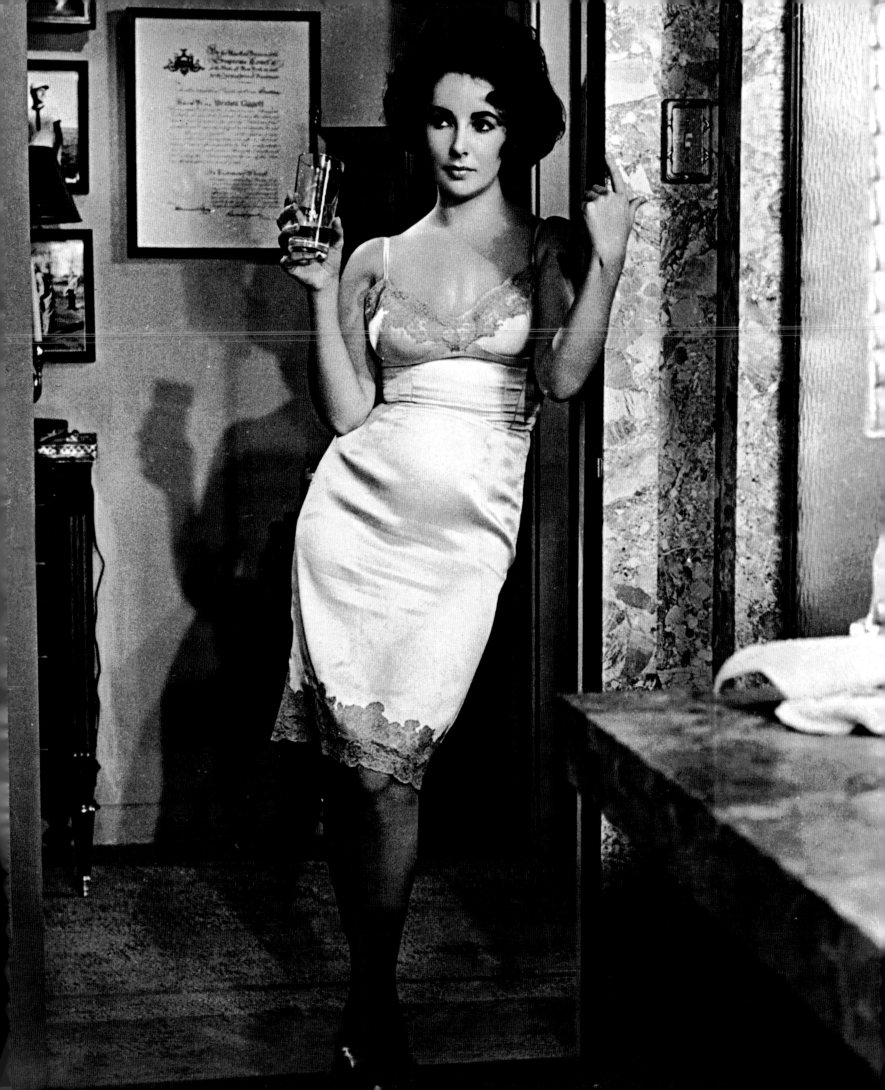

right
As fashion forecasters predict a return to glamour after years of sports and workwear, so red hair is appearing on the catwalk. Lily Cole, a natural redhead, models a look that evokes the late 1940s glamour of film star Rita Hayworth at Julien Macdonald's Autumn/Winter 2005 show.

opposite
Karen Elson's natural red hair was teased into a soft tumble of curls for this Vogue **shoot by Karen Collins.** (2004)

way of shocking one's parents as a teenager. Blondeness 'raises the flag of sexual intent'[33], or, as for Madonna, signifies self-determination and a new kind of feminism for women who love playing with their appearance for appearance's sake. But for most people nowadays hair colouring is not meant as a radical statement; it is no longer a niche market but has become a mainstream beauty activity for both men and women. Colour can be all-over, creating an intensely glossy sheen, or can take the form of highlights or lowlights for an enhanced natural look; particularly renowned for her tinting is hairdresser Jo Hansford (who started out with Vidal Sassoon but now has her own salon in Mayfair). It is now estimated that almost half of all women have coloured hair in the 2000s. In many ways colour is a way of life and has taken over from cut in fashions for hair.

There will always be a new hair frontier to cross.[34]

chapter three: Cut

Hair grows and so must be cut. Traditionally short, cropped hair was not a personal choice but forced upon prisoners or slaves, making them conform to social rules. The brutish crew cut of the American forces makes a man a homogenous member of a fighting force, but becomes a utilitarian reactionary look when worn by skinheads as a Number One. The skinheads of the 1970s favoured a look that was harder and more menacing, to differentiate themselves from the vague, soft

above left

The skinhead crop of the early 1970s has entered the vocabulary of street style and signifies a hard masculinity in opposition to hippie softness. This version dates from 1980.

above right

Singer Grace Jones, an icon of 1980s post-punk androgyny, styled by Jean-Paul Goude and with a 'Fade' cut by Dutch session stylist Christiaan.

hippie look of the late 1960s, and championed the functional, moonstomping in button-down Ben Sherman shirts, Sta-Prest pants or Levis held up with braces to reveal the ubiquitous Dr Marten boot – previously worn as protective footgear in factories but now used quite literally to 'put the boot in'. By the mid-1980s the crop, as worn by Sinead O'Connor, Annie Lennox and Grace Jones, was associated with androgyny, and the skinhead look was wittily subverted in gay club culture. Later this became the apotheosis of cool when worn by rapper Tupac in the 1990s.

Haircuts are no mere simple incursions into hair taming and conformity. The haircut is a living, growing embodiment of cultural codes and meanings and can turn someone into a walking work of art. The 'normal' of the 1930s may have been a mainstream choice of men wary of the vagaries of fashion, but for others cuts sparked social revolution. The bob is a case in point, a move by women away from the physically restricting and uncomfortable styles of the Edwardian era to something more practical and *sportif*. Celebrity hairdresser Antoine had cut one of the first bobs in 1911 for the actress Eve Lavallière. As he

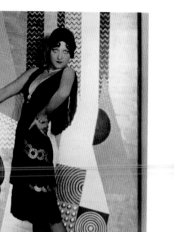

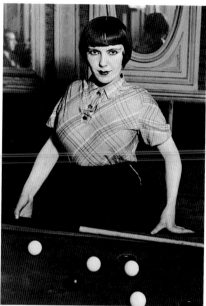

put it: 'a bell rang inside my head. The time had come for
women to have their hair cut short. This new automobile in
which women sat open to the winds, these new women with
careers, this busy life. And these changing clothes, which
demanded small, neat heads, not enormous masses of hair.'[35]
By the early 1920s the bobbed hairstyle was beginning to catch
on and perfectly complemented the clothes of designers such
as Coco Chanel, Elsa Schiaparelli and Madeleine Vionnet. The
new neat chic look, with its androgynous low-waisted and
flattened shape, was part of the modernist revolution whose
clean lines could also be seen in a Bauhaus chair and a New
York skyscraper. It was soon popular, and as one flapper
observed: 'All the young women at the office were having their
hair cut short... my mother and I went to the hairdressers on
Wardour Street, where we sat at the end of a long queue of
women who, like us, were patiently waiting to let down their
beautiful long hair. An hour later, with hats too large for our
diminished heads, feeling very self-conscious, anxious to be
home where we could make a minute, pitiless examination of
our changed appearance, we emerged as new women.'[36] It has
been estimated that during one week in 1924, 3,500 women

above left

**The Art Deco style of the 1920s
was a popular manifestation
of Modernism, as was the bob
haircut and more streamlined
fashion silhouette.** (1929)

above right

**A girl playing snooker in Paris
photographed by Brassaï. The
chic 'box bob' haircut had been
adopted by the majority of
European women by this time.**
(1932)

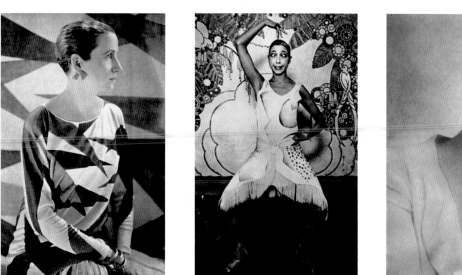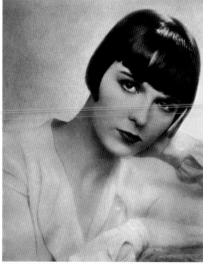

were bobbed in New York and hairdressers learnt to have smelling salts at hand in case the move from long to short hair was too much of a shock; one newly shorn woman revealed: 'I must say that first snip of the scissors gave me a shock like a cold bath or taking gas.'[37] The bob heralded a tubular look, with bodies streamlined by slim-fitting jerseys and knee-length skirts, topped with a cloche hat.

As the 1920s progressed cuts became increasingly shorter and included shingles, bingles and the severe 'Eton crop', which was worn most successfully by Madame Agnès, as photographed by Edward Steichen, and stage star Josephine Baker, whose 'bakerfix' hairstyles were invented by Antoine de Paris. He slicked her hair close to the scalp and brilliantined it into a highly polished reflective surface. In 1926 Aldous Huxley described Lucy, a character in his novel *Point Counterpoint*, as being 'blue round the eyes, a scarlet mouth and the rest dead white against a background of shiny metal-black hair'; he could have been describing Hollywood sensation Louise Brooks, with her trademark chic black bob. By 1928 Cecil Beaton realized that 'Our standards are so completely changed from the old that

above left

Madame Agnès photographed by Edward Steichen in 1925. Her geometric, Cubist-inspired tunic and slicked-back 'Eton crop' are a perfect match of fashion and hair.

above centre

Singer and actress Josephine Baker starred in Les Revues Nègres **in 1920s Paris. Her 'bakerfix' sleek hairstyle was devised by celebrity hairdresser Antoine.** (1940)

above right

Louise Brooks' black shiny bob, as seen in her role as prostitute Lulu in the film Pandora's Box **(1928), defined the look of a generation.** (c.1920s)

opposite

Swimwear photographed for Vogue **by Russian-born photographer George Hoyningen-Huené in the 1930s. The stark geometric style of the modernist backdrop is echoed in the cropped hair of the models.**

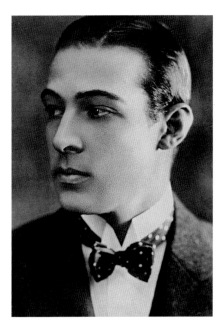

above left

An androgynous look of the 1920s with a bob haircut and a more extreme 'Eton crop' appropriated by modern women from schoolboy hairstyles. (1925)

above right

Rudolph Valentino was the world's most popular male film star in the 1920s thanks to his starring role in The Sheik (1921). His slicked-back, shiny brilliantined hair became a very popular male fashion. (1926)

comparison is impossible. We flatten our hair on purpose to make it sleek and silky and to show the shape of our skulls, and it is our supreme object to have a head looking like a wet football on a neck as thin as a governess' hat-pin.'[38] Rudolph Valentino epitomized this look for men, his hair swept back with a glossy sheen.

Bobbed hair, then, was a sign of the times, a new look for women eager to escape the conformity of the Edwardian years. It provoked an outcry in the popular press, who envisioned Amazonian women causing disruption in the codes of gendered dress and thus the unwritten rules of society. A religious tract entitled *Bobbed Hair: Is it Well-Pleasing to the Lord?* ran: 'A bobbed woman is a disgraced woman! What will the Lord say to our sisters about this when we all stand at his judgement seat? The refusal to utter the word "obey" in the marriage service, the wearing of men's apparel when cycling, the smoking of cigarettes and the "bobbing" of the hair are all indicators of one thing! God's order is everywhere flouted.'[39] The bob was more than a haircut – it suggest real cultural change in the way that women thought about themselves and their place in society. It

mirrored their increasing social and economic independence and displayed a love of fashion – which explains why they didn't grow their hair long again for forty years.

By the 1950s the hairdresser reigned supreme and the cut was seen as the foundation of any good hairstyle. Guillaume, Alexandre, Freddie French and Raymond 'Teasy-Weasy' Bessone stalked the salons, proclaiming this season's look in the same way as the great French couturiers Dior, Balenciaga and Balmain were dictating hem length and silhouette from their ateliers in Paris. Raymond had annual shows at the Café de Paris in London where he displayed his new cuts for the first time, and these were as avidly followed as the seasonal catwalk collections. Saint-Laurent may have had his H line but Raymond had the Chrysanthemum and Champagne Bubble Cut of 1956 followed by the Boom line of 1960. Dior's New Look silhouette was the dominant mode of the day, making women, as he put it 'women-flowers [with] soft shoulders, flowing busts, fine waists like liana and wide skirts like corolla.'[40] Rigorous bras moulded breasts into points and constricted waists into tight-fitting bodice tops, girdles held the stomach in and were then

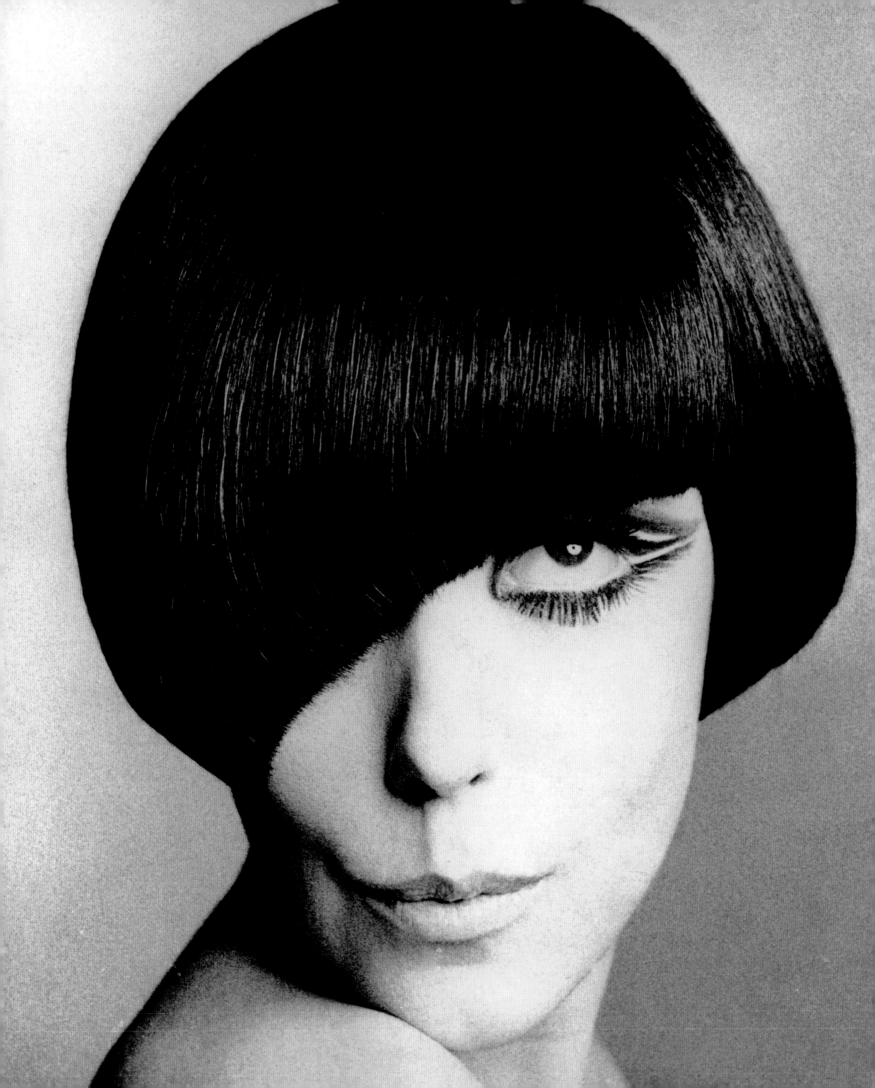

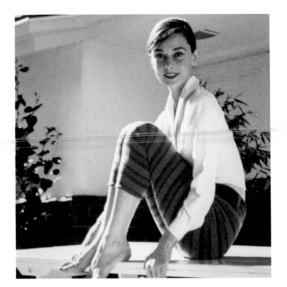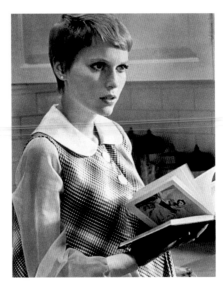

surrounded by crinoline skirts with petticoats of stiffened organza and net. Hair was as high-maintenance as high fashion – *haute coiffure* that had to be rigid; not a hair was allowed out of place. Poodle cuts, pageboys and the gamine Audrey Hepburn style were amongst the most popular of the 1950s until the clean lines of Vidal Sassoon blew them away. His 'Five Point cut' and reinterpretation of the 1920s bob for Nancy Kwan were perfection, using Bauhaus principles for pared down hair that swung like the 1960s. The cut was now the focus, not just the foundation, of hairdressing. In 1967 he cut Mia Farrow's hair into a shorter than short crop for the film *Rosemary's Baby* on the sound stage of Paramount Studios in front of a hundred journalists:

It sounded as if it was halfway between Stage 13 and Heaven – a jazz quartet was playing cool, cool music. Somewhere much nearer the ground a movie camera began to whirl. I put a gown around Mia. I picked up my scissors. I made the first cut, feeling now like a high priest at a royal sacrifice. I don't know what the Paramount boys were expecting when they had erected their little rope barrier. But for once they had not thought big enough.

above left
Audrey Hepburn played a gamine-cut beatnik girl turned fashion model in Funny Face **(1957). She starred opposite Fred Astaire who played a fashion photographer based on Richard Avedon.**

above right
Actress Mia Farrow in the horror movie Rosemary's Baby **(1968). In one seminal scene she has her hair cut into this chic crop at Vidal Sassoon, New York.**

opposite
The 1960s model Peggy Moffitt, muse and wife of fashion photographer William Klein, in a geometric bobbed haircut by Vidal Sassoon. She still sports a Sassoon 'Five Point cut' to this day. (1966)

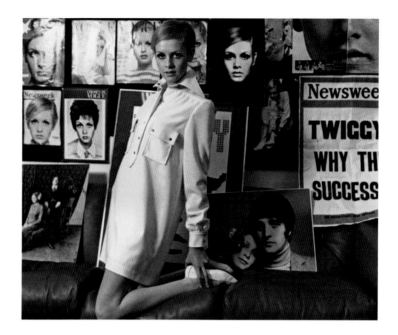

above right

Twiggy's modelling career was kickstarted with a haircut. Her new version of the Eton crop by Leonard made her the face of the 1960s. (1967)

If they had known what was going to happen, they would have laid mines and anti-tank traps. The first lock of Farrow hair had scarcely hit the apron when the Press were down from their seats, across the twenty yards to the ropes, over them and on top of us. They weren't just breathing down my neck. They were damn near breaking it. They crowded and pushed, hung out of the rafters and lay on the floor. And all the time I was dancing round that small blonde head, snipping here, flicking a comb there, using the ring, jostling and being jostled, while the flash bulbs popped and the jazz band played, unheard now and forgotten. It was a psychedelic scene.[41]

Farrow's neurotic little-girl-lost look, encapsulated in her wide-eyed Bambi stare, shorn head and mini dresses revealing long lean limbs, became one of the defining looks of the 1960s, as did Twiggy's crop by Leonard Lewis. For men the most revolutionary haircut of the 1960s was the Beatles moptop. It was derived from the 1950s Caesar, to which German student Astrid Kirchherr added a fringe for her boyfriend Stuart Sutcliffe – at that time a member of the band – when the Beatles were playing in Hamburg before their fame. The other Beatles followed

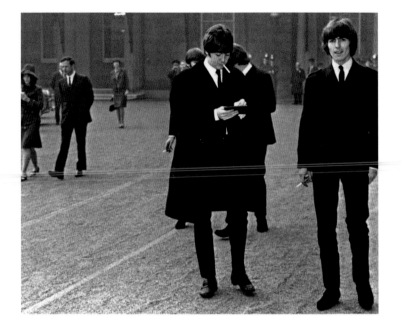

suit, cutting off their greasy rocker quiffs and combing their hair forward instead of back. Kirchherr then went on to make Stuart a collarless black jacket based on the catwalk designs of Pierre Cardin, which caused a bit of consternation: 'The others teased him; "What are you doing in Mum's suit, Stu?" but later – after Stuart's death – when Brian Epstein decided they needed a cleaner image, they revived the collarless suit and, like their elastic sided boots, it became a symbol of the group.'[42] Under Epstein's guidance Leonard Lewis sharpened up Kircherr's 'pudding-basin style, which they didn't look comfortable in. I set about softening the look and giving them a style that would move about and always look good, even when they were shaking their heads on stage. The boys seemed happy with what I did, though they were nervous that they might get picked on by other men for looking too "girlie". When the band burst on the scene with their mop tops, there were a lot of jokes about "not being able to tell boys from girls". But a corner had been turned and men's hairstyling would never be the same again.'[43] Bob Hope led the backlash: 'I see the Beatles arrived from England. They were forty pounds overweight, and that was just their hair.'[44]

above left

The Beatles with hair by Leonard Lewis of Mayfair in the 1960s. Their moptop hairstyle was so popular that Beatle wigs were made so that teenagers could emulate the look without upsetting their parents. (1965)

**Actress Joanna Lumley, now
probably best known for her
portrayal of Patsy in** Absolutely
Fabulous, **in an earlier incarnation
as special agent Purdey in**
The New Avengers. **The Purdey
cut was a key look of the
mid 1970s.** (1976)

**Trevor Sorbie invented the
seminal wedge cut in 1974, an
aerodynamic shape originally
intended for women but taken
up by young men involved in
the London soul scene.**

Soul and disco spawned iconic cuts. Trevor Sorbie's wedge cut
of 1974, the first cut to appear on the cover of *Vogue*, was
architectural and technically supreme – it comprised a side
parting and a floppy fringe which was swept around to the back
and dyed darker underneath to emphasize the wedge effect.
Writer Peter York saw it as revolutionary: 'Bare necks, visible
ears, with bouncing subversive hair top. What could be more
irritating than this long–short combination?'[45] Soul boys and
girls wore the wedge with Fiorucci peg-top trousers (later
dubbed Bowie Bags after David Bowie changed his haircut
to a blonde wedge and wore plastic sandals in *The Man
who Fell to Earth* in 1975), white socks and low-cut loafers
with Benetton sweaters tied loosely around their necks. The
Purdey cut was a similar style sensation based on Joanna
Lumley's character in *The New Avengers*, who had a haircut
that defined a generation of women in the same way as
Meg Ryan's choppy bob in the 1990s.

By 2000 men were investing more and more imagination in
their hair, inspired by the catwalk designs of Guido Palau for
Gucci and Karl Lagerfeld, Anthony Mascolo of Toni and Guy and

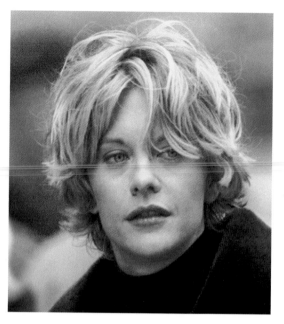 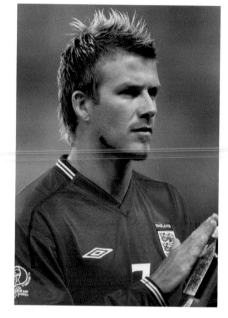

Gianni Scumaci of Vidal Sassoon, and began sporting variants of a cut known as the 'Hoxton fin', so called because of its associations with a fashionable area of the East End of London which was being gentrified by artists and media professionals. The Hoxton fin was a hybrid of the punk Mohican of the late 1970s (which by the 1990s had become a conventionalized signifier of youth rebellion) and the 1980s mullet, a reviled style worn only by post-modern ironists and trailer trash. The Hoxton fin went on to spawn its own stereotype, 'typically called Floyd or Sebastian, [who has] a really overpaid easy job in the media, buys all [his] clothes from Newburgh Street, and has the latest copy of *Sleazenation* sticking out of the back pocket of [his] ridiculously low-sling Evisu jeans. And they all ride micro scooters too.'[46]

A haircut, then, can provide a tonsorial touchstone as emblematic of a decade as a chair design or skirt length. Yet haircuts can never be truly controlled – you only have to look in the mirror in the morning to understand that – and that's where their magic lies: there for a moment, and then blink and they're gone.

above left

American actress Meg Ryan has one of the world's most copied haircuts. Her choppy razored mid-length cut was created by hair stylist to the stars Sally Hershberger. (1998)

above right

David Beckham's fin haircut originally created by Tyler of Vidal Sassoon has become the most copied haircut for men in the 2000s, appearing on every high street in every city. (2002)

Beyoncé without curls is like vodka without tonic.[47]

chapter four: Curly

Curls are considered a nightmare or a blessing, hated by those who were born with them and coveted by those with limp locks. Whether natural or permed, curls have been absent in fashion since the 1980s and many stars rarely appear *au naturel*, preferring to have sleek, ironed hair. Minnie Driver and Julia Roberts are two of the most notable. The quest for permanent curls has been a long and complicated one, a 20th-century holy grail, and the marcel wave was one of the early successes.

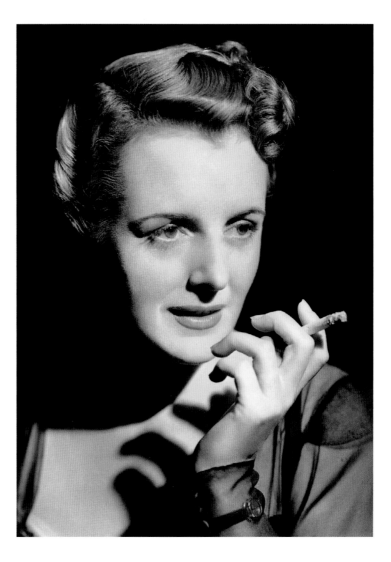

right

The marcel wave became a staple technique used in hairdressing salons right up to the 1940s, created by pressing a temporary undulation into the hair with hot tongs. (c.1940s)

Invented in *fin de siècle* Paris by Marcel Grateau, it consisted of a temporary wave put into the hair by tongs heated over a gas burner and, if not washed out, the waves could remain in the hair for up to two months. Marcel waving was all the rage by 1917 when French hairdresser Emile Long observed that 'now there is not even a modest work-girl or shop assistant who does not resort to its infinite possibilities,'[48] but Antoine de Paris remained unconvinced and complained that marcelled hair resembled 'the general lines of the rougher part of a washboard.'[49] The marcel was eventually supplanted by the perm (permanent wave), which was invented by Charles Nestle in 1909. For his process the client's hair was 'encased in asbestos and baked for ten minutes by means of a specially and ingeniously devised electrical heater hanging from a

 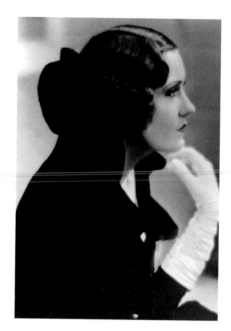

bracket in such a manner as to take all the weight from the head.'[50] It was an arduous and painful process, and a full head of curls could take up to 10 hours to complete. Thus the collective memory of early perms was one of pain: 'It must have been about 1928. First our hair was washed and cut. My hair was wound up on spiral rods so tight that I thought I would never blink again. It all began to steam and tears rolled down my cheeks; maybe this was just a part of being beautiful. Afterwards I looked like I'd stuck my finger in a light socket.'[51]

Perming really took off in 1930s as bobbed hair was the easiest to perm and curls fitted in with the newly glamorous and fashionable look adopted by such Hollywood stars as Carol Lombard, Gloria Swanson and Barbara Stanwyck. Women wore snappy suits in classic shapes with fox-fur stoles, while others preferred draped dresses in chiffon or rayon with floral prints worn under peplum jackets by Molyneux or Mainbocher. Combined with the perm, this created an intensely feminine look, a complete rejection of the 1920s androgyne. Curled and dressed hairstyles continued into the 1940s, and many ingenious methods were adopted during a wartime that

above left

Actress Barbara Stanwyck with permed and set hair in a typical Hollywood glamour shot, complete with white fur and diamonds. Natural hair was set and sprayed into submission until the hippie revolution of the 1960s when unrestrained hair was permissible in fashion. (1949)

above right

Hollywood actress Gloria Swanson with a finger-waved bob in 1927. The 'box bob' of the earlier 1920s was gradually softened using a variety of new curling techniques as the decade progressed.

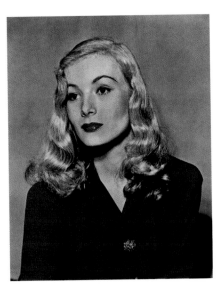

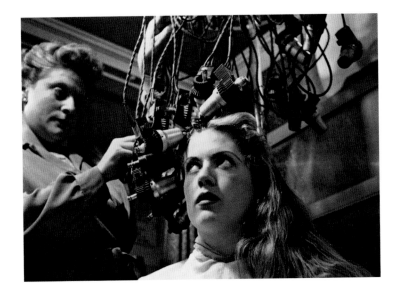

above left
Veronica Lake's peekaboo hairstyle was one of the most popular of the 1940s, when it was difficult to go to the salon because of wartime restrictions. Hair could be grown long and curled with rags or papers at home. (1941)

above right
Perming machines could be found in most hairdressing salons until they were rendered obsolete by the chemical perm in the 1950s. To curl a head of hair in this way would take at least 10 hours. (1954)

opposite
Joan Crawford was one of the most popular Hollywood actresses of the 1930s and 1940s, and maintained a strict diet and beauty regimen to keep herself at the top. Her bobbed and curled hairdo was typical of 1930s hair fashions. (1935)

brought economic hardship and austerity. Sugar and water and pipe cleaners were used to create curl and many women resorted to covering up a bad hair day with turbans. Veronica Lake's peekaboo hairstyle was one of the most copied: its lush femininity stood out in a sea of Utility suiting. As the fashionable silhouette became boxier and square-shouldered in heavy hard-wearing materials of muted colours, hair became more and more feminine, harking back to the opulence of the Edwardian era; Joan Crawford's dressed hair, full mouth and sculptured jackets by Adrian exemplified the total look.

The 1950s ushered in a renaissance of the perm, in particular the home perm. Soapless shampoos and hair conditioners appeared in the shops, and haircare became a domestic activity full of feminine beauty rituals. But a woman's beauty aids had to be kept secret from her husband. One beauty book read: 'Most men are interested in results, not in how you obtain them. Do not discuss your methods with your husband. He will be aware that you have a permanent and hair settings, but he wants only to admire the finished effect. Will you remember this? Because when you have learned it well and apply it always, you will know

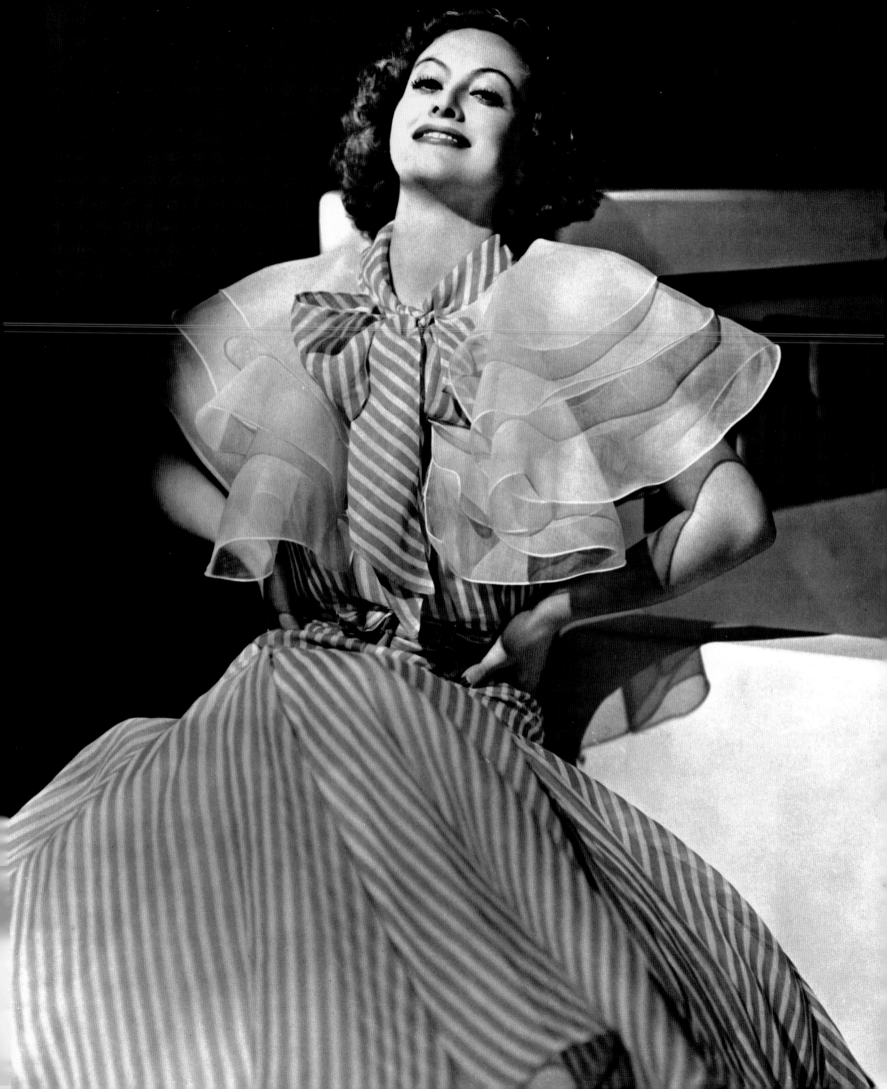

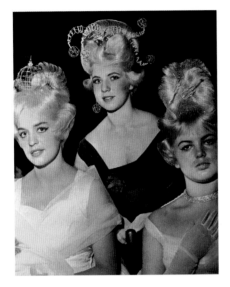

above

In the 1950s hairdressers showed their expertise at cut, colour and finish in competitions creating 'fantasy' hairstyles. This 'Vienna Waltz' collection is from 1959.

the most vital secret of feminine seductiveness.'[52] The new ranges of beauty products, many of which evolved as a result of scientific developments designed to help the troops in wartime, made the most fantastic styles possible – aerosol hairspray, for instance, came out of the need for insect repellant in the Pacific. Women had shown enormous ingenuity throughout the war years when they were starved of all luxury, and during the 1950s they displayed a similar inventiveness, making the most of everything available to them. Hairstyles became fuller and more bouffant and then beehived, backcombed into high puffballs using perms and rollers and fixed with hairspray. Going to the beauty shop for a permanent wave gave women a real sense of community. In one such shop, 'Patty Jane kept a drawer full of cotton bandanas spritzed with dimestore perfume – *Tabu* and *Evening in Paris* and, occasionally, *My Sin*, which I thought was as chic as chic could get. I helped out at the House of Curl after school and on Saturdays. Whenever anyone stank up the place with a permanent wave, I would be called upon to distribute bandanas and tie them carefully, the way a nurse ties a doctor's surgical mask, over the nose and mouth of the customers. Everyone in the shop wore them so that the room looked overtaken by a bunch of Old West bandits assembled for a Dippety-Doo heist.'[53] Similar to the bouffant, the beehive, whose very foundations were created by the perm, became synonymous with a particular kind of 1950s kitsch later beloved and immortalized by director John Waters, whose 1988 film *Hairspray* pays homage to the style. Similar deference was shown by singer Mari Wilson in Britain in the early 1980s and the B52s in the US, whose girl singers sport massive bouffant wigs.

The 1960s was a sleek hair decade until the hippie movement, which called for untreated locks left wild and natural. Instead of blow-drying or ironing their hair as before, many left it long, free and kinky, and those who had no curl had resorted to a chemically enhanced kinkiness by the 1970s. Barbra Streisand had a bubble perm, short and curly all over (a kind of white Afro), and men began to buy into the curly look. Footballer

 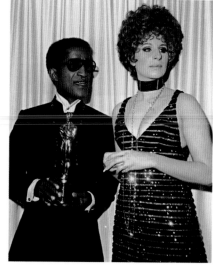

Kevin Keegan, actor Martin Shaw and singers Leo Sayer and David Essex wore their curls with head held high, whether they were natural or processed, while singer Robert Plant refused to cut his hair, saying 'I'll end up looking like a waitress in Santa Monica. There's something wrong with curly hair when it's short.'[54] Chaka Khan and Diana Ross had enormous heads of curly hair by the 1980s and singers Lionel Richie, David Grant and Michael Jackson popularized the wet look 'Jheri curl' invented by Jheri Redding. This was the first process to turn kinky black hair into true curls, building on the work of Willie Lee Morrow's 'Tomorrow curl' of 1966. Women clung to the curl, and the 1980s became the decade of the perm, with such stars as singer Kylie Minogue undergoing the process and then leaving their hair in its chemically enhanced kinky state rather than having a full spiral perm. Perhaps it was this perm overload and memories of hairdos gone wrong that have banished the curl for the last decade. Journalist Michele Kirsch finally declared the perm dead in 1996, writing: 'Hair straightening is all the rage. Nothing typecasts a girl quite like a head of curls. In her late teens and twenties she is a new-age hippie. In her thirties she is too cerebral to bother. In her forties and fifties

above left

Post-punk band the B52s play with the legacy of American high kitsch of the 1950s and early 1960s. The girl singers heighten the performance of such songs as 'Love Shack' and 'Rock Lobster' by wearing huge beehive wigs. (1980)

above right

One of the famous Rat Pack, Sammy Davis Junior wore straightened and pomaded hair, never an Afro – unlike superstar Barbra Streisand, whose bubble perm was a white version of a black hairstyle. (1968)

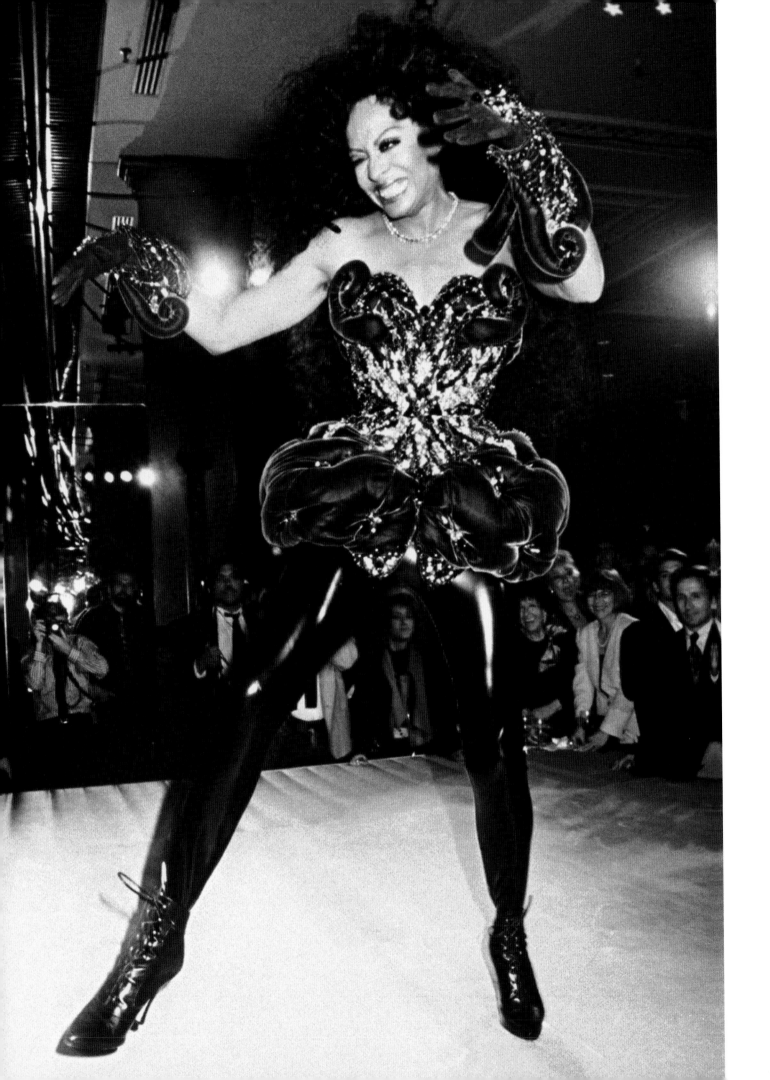

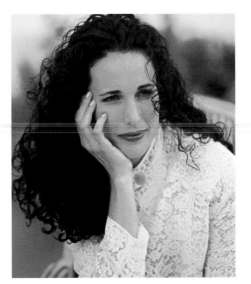 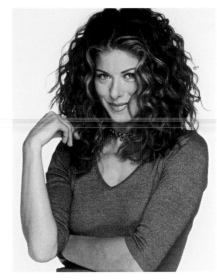

she is an ageing hippie. In her sixties she can go for the Miss Havisham look.'[55] With a few exceptions, such as actresses Andie MacDowell and Debra Messing of sitcom *Will and Grace*, most men and women want their hair straight.

The tide is turning, however, and after years of straighter hair a cultural shift is occurring, thought to have been inspired by Orlando Pita's curly styles created for the Gucci catwalk show of 2001, Daniel Hersheson's 'wavy gravy', or loosely curled styles, and fashion icon Sarah Jessica Parker's mane of curls in *Sex and the City*. Madonna and Kylie Minogue have been experimenting with texture, and Jennifer Lopez is more of a blow-dry free zone of late. The logic of fashion demands that curls are ripe for a renaissance.

above left
Actress Andie MacDowell, who is a naturally curly brunette, is perhaps best known for her appearance as Hugh Grant's love interest in Four Weddings and a Funeral **(1994).** (1996)

above right
Debra Messing of the American television series Will and Grace **has resurrected the reputation of both curly and red hair. The fashion for ironing and straightening long hair has made natural curls an unusual sight.** (1999)

opposite
Diana Ross, originally a 1960s Motown artist, is one of the world's most successful female singers. During her long career Ross has sported hairdos as diverse as a Sassoon-style wig and a late 1960s Afro, as well as her trademark waist-length curls. (1993)

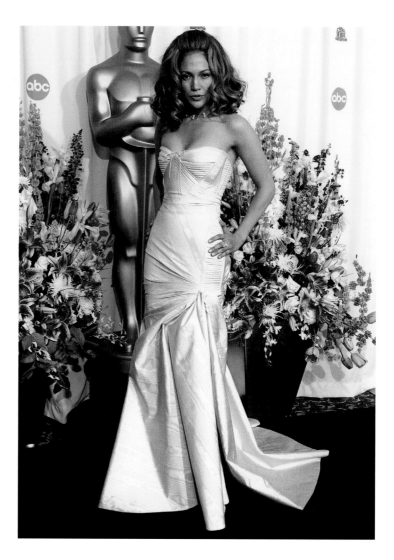

above left

Supermodel Kate Moss regularly reinvents herself through her changing hairstyles. On her 30th birthday she chose a head of ringleted hair extensions. (2004)

above right

Actress Jennifer Lopez appeared at the 2001 Oscar ceremony with a retro look based on a 1960s bouffant shape by hairdresser Oribe.

opposite

With her Manolo Blahnik heels, and vintage and designer gear as styled by Patricia Field, Sarah Jessica Parker as Carrie in the HBO series Sex and the City **has become a fashion icon while retaining her naturally curly hair.** (2001)

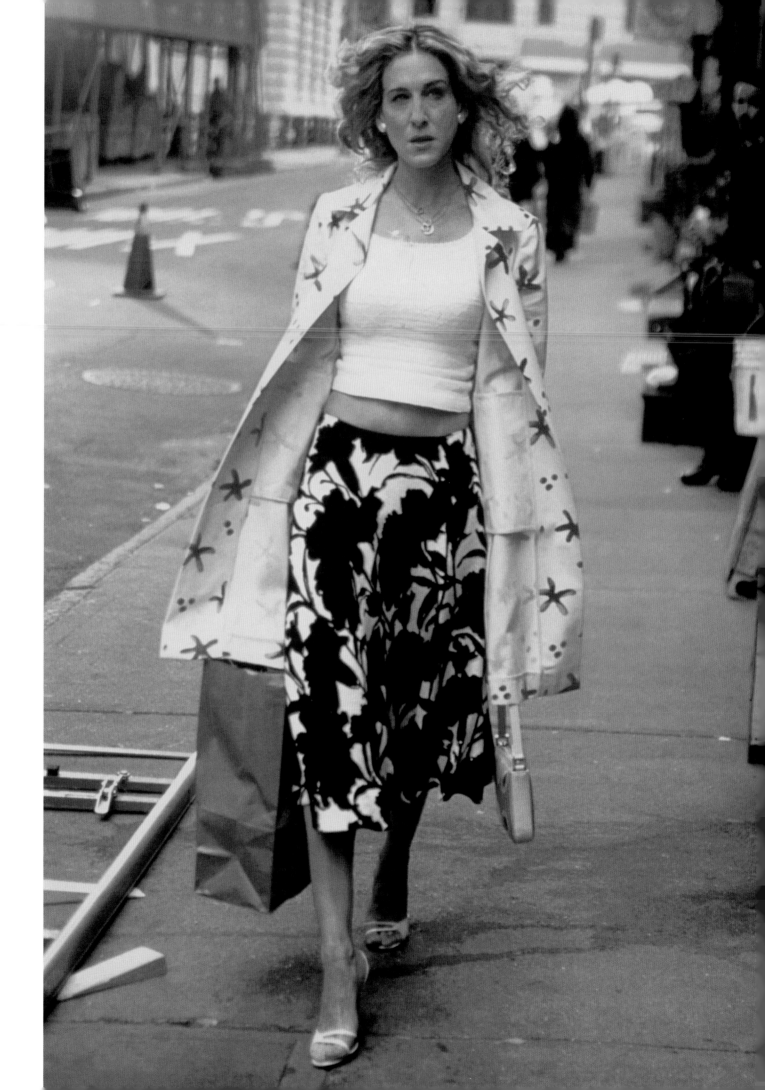

I like that platinum on your wrist. But why is there no ice in this?
Same reason why, baby girl, that ain't your hair. We both frontin'.[56]
We both frontin', Mace, 1999

chapter five: Fake

People have always faked it. Artificial hair
in the form of wigs and hairpieces is used to
supplement impoverished locks, can be a
cunning disguise for rampant baldness or
worn as a glaringly obvious fashion statement
– Beyoncé Knowles' and Britney Spears'
extensions are an expression of twenty-first
century pop sensibility. In the past, wigs were
worn in many cultures as status symbols because
of their cost – only the rich could afford them –
and in Ancient Egypt, for instance, the wearing

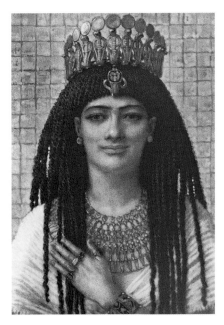

above left

At some point in the history of most cultures, people have worn fake hair. The Ancient Egyptians used some of the most extravagant wigs as a mark of social status.

above right

The Edwardian S-shaped silhouette was achieved with corsetry. Hair was elaborately dressed and bulked out using false pieces called postiche.
(1902)

of wigs denoted high rank. The hairstyles of the late Victorian and Edwardian era were of such dimension they demanded a mixture of natural hair mixed with fake in the form of fronts and transformations. The building of Edwardian hairstyles in particular was dependent on the use of *postiche*, the French for 'added hair', and styles included fringes, switches, pompadour rolls and frizettes. The fashionable ideal was voluptuous and statuesque; Lucile, one of the era's most influential couturiers, refused to use models under six foot tall and less than 154 pounds in weight, and big girls with fine figures and abundant hair were considered the most beautiful. The ideal body was achieved through plenty of corsetry and frou frou, frills and lace. Blouses with puffed sleeves and heavy floor-length skirts and gowns of rustling silk were topped with immense hairdos under Gainsborough picture hats, which added to the Junoesque look. Lady Violet Hardy recalled 'Enormous hats often poised on a pyramid of hair, which if not possessed, was supplied, pads under the hair to puff it out were universal and made heads unnaturally big. This entailed innumerable hairpins. My sister and I were amazed to see how much false hair and pads were shed at "brushing time".'[57] The Edwardian fashion

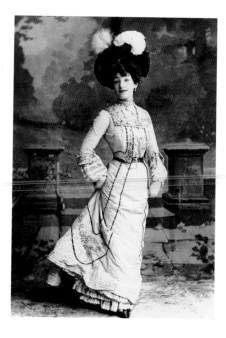

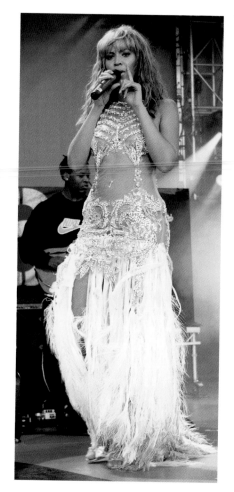

for large hats was also seen as bad for the hair. One West End specialist wrote in 1910 that 'as grass grows yellow under a mushroom, so women's hair will lose its colour and deteriorate under the gigantic hats which are now the mode. There is every possibility of the fair sex going bald unless a revolution in hats is effected.'[58]

The hair that was used to create *postiche* was bought from working-class women, whose crowning glory was a commodity to be exploited, or from those who had fallen upon hard times. In one of the most famous scenes in children's literature, Jo March in Louisa May Alcott's *Little Women* (1886) sells off her long hair for the sake of the family purse:

She came in with a very queer expression of countenance, which puzzled the family as did the roll of bills she laid before her mother. "My dear, where did you get it? Twenty-five dollars! I hope you haven't done anything rash?"
"No, it's mine honestly; I didn't beg, borrow or steal it. I earned it; and I don't think you'll blame me, for I only sold what was my own."

above left
Edwardian fashion called for height, which was achieved through tall, dressed hair topped with highly decorative millinery. (1905)

above right
Beyoncé Knowles of R&B group Destiny's Child has carved out a successful solo career in the 2000s. She is known for her hair experimentation and uses a variety of false extensions. (2003)

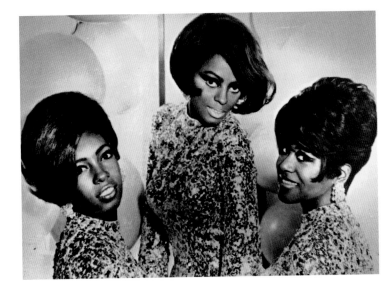

above left

The Supremes, the most successful girl group of the 1960s, were known for their vast collection of wigs, which in the 1960s formed part of most women's wardrobe. (1965)

above right

The Supremes, left to right, Mary Wilson, Diana Ross and Cindy Birdsong. (1968)

As she spoke, Jo took off her bonnet, and a general outcry arose, for all her abundant hair was cut short.
"Your hair! Your beautiful hair!"
"Oh, Jo, how could you? Your one beauty."[59]

The Hair Market at Morlans in the Pyrenees was one of a number of hiring fairs where dealers literally bought the hair fresh from the head. Wigs were also fashioned of imported hair from Asia Minor, India, China and Japan – a tradition that continues to this day.

Wigs fell out of favour with the introduction of the new bobbed hairstyle in the 1920s. They made a reappearance in the 1950s but only as a way of creating temporary fantasy hairstyles for hair competitions and shows, and were fashioned by the most renowned wigmakers and hairdressers in Europe, such as Maria and Rosy Carita. In black hairdressing, however, the wig was of supreme importance, as it allowed women to have fashionable styles without having to undergo the time-consuming and in some instances painful process of straightening. In the mid-1960s, black stars such as Diana Ross and the Supremes were

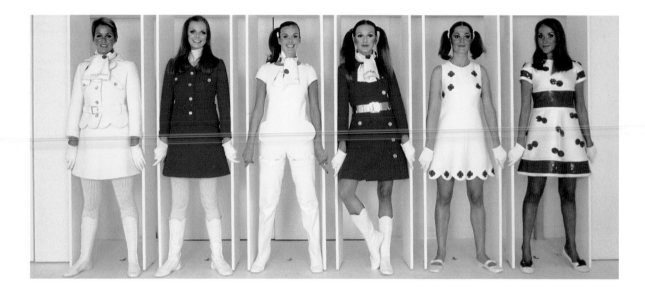

known for their stylish wig collections. Supreme Mary Wilson remembers: 'We had dozens of them, all expensive, handmade human hair pieces in a variety of styles ranging from mod-ish Vidal Sassoon cuts to high, elaborate flips. In fact the bulk of our luggage was made up of huge wig boxes.'[60] It was not really until the late 1960s, however, that wigs underwent a massive renaissance in white hairdressing practices. Rapidly changing fashion, a space-age chic and the vogue for drip-dry clothes in new man-made fabrics led to a preference for the artificial over the natural. André Courrèges, Paco Rabanne, Pierre Cardin and Emmanuelle Khanh sent skinny models in brilliant white scampering down the catwalk, making the future part of the present. The simple shift dresses of Mary Quant were easy to wear and relatively cheap, and women wanted their hair to be as capricious as their fashion. The easiest way to do it was with a wig. By 1968 there was a wig boom and it is estimated that one third of all European women wore what hairdressers called a 'wig of convenience'. The invention in Hong Kong of the machine-made, washable nylon and acrylic wig led to cheap, mass-produced wigs flooding the market, and the novelty fashion wig or hairpiece became one of the key parts of a

above

André Courrèges, part of the Parisian 'ye ye' group known for their space-age designs and use of synthetic fabrics, helped popularize the 1960s love of all things artificial, which included wigs. (1968)

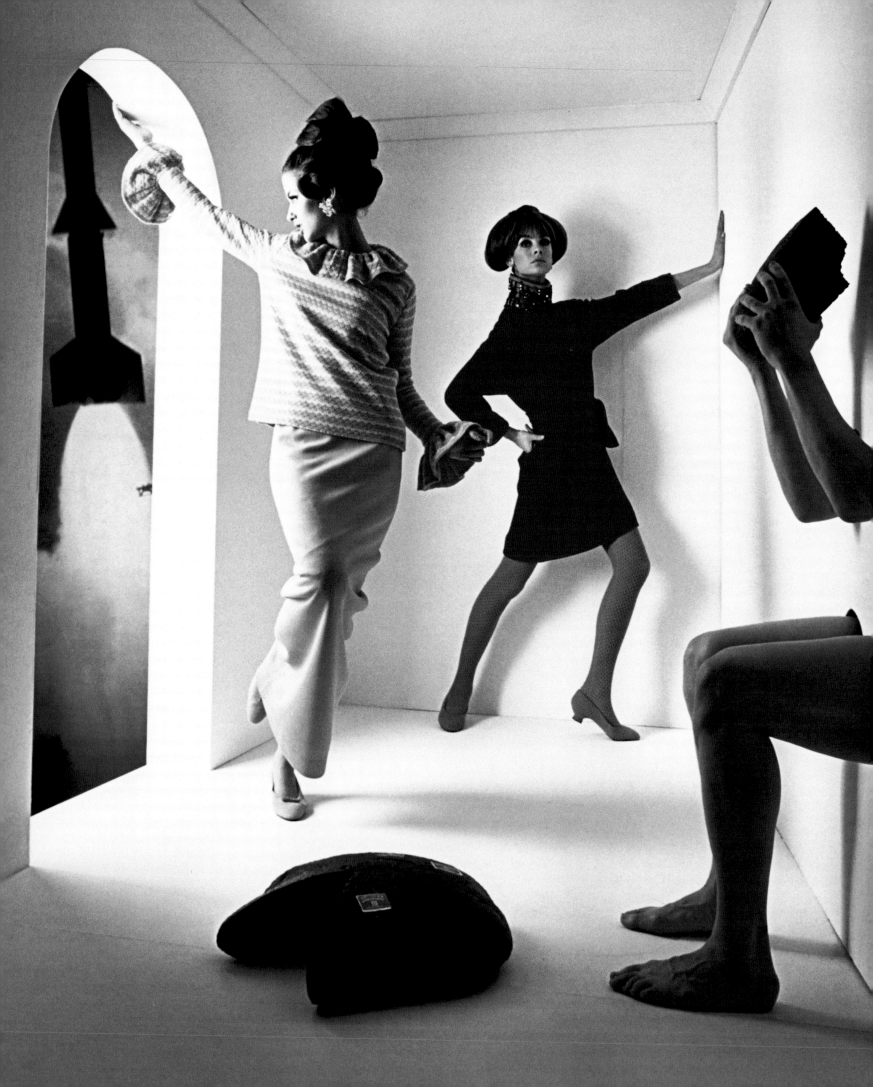

left

**Andy Warhol, the New York
Pop artist and brains behind the
Factory (an assortment of artists,
philosophers, actors and musicians),
had over 30 wigs, which now reside
in the Andy Warhol Museum.**
(1960)

opposite

**Pop art made the artificial
fashionable and its influence was
felt in hair and fashion. A pop
sensibility is used to full colour
effect in this image from 1964.**

fashionable woman's wardrobe. Men followed the trend too, and Lisa Wigs in the US marketed a fake moustache, sideburns and beard set to transform executive man into swinging playboy. The high-fashion safari suit, originally designed by Yves Saint Laurent, completed the look. Perhaps the most experimental wig wearer in the late 1960s and '70s was Andy Warhol, who owned over 30 in various shapes and sizes, all in shades of silver-grey. Wigs for him were part of his performative art project, embracing and celebrating the artificiality of consumer culture. Obsessed with the cult of celebrity, which he examined in his Pop Art portraits of Marilyn Monroe and Jackie Kennedy, he constructed his own, highly individual image using dark glasses and increasingly bizarre silver fright wigs, ultimately becoming a celebrity himself.

above

Not only women wore fashion wigs in the 1960s and '70s. Some brave men were prepared to experiment with a variety of hairpieces, fake sideburns and even chest wigs. (1970)

In the late twentieth century many false forms of hair are used and the change from a long to a short hairstyle can be made at a whim with sophisticated forms of extensions that have crossed over from black hairdressing to white. Black hairdressing has always celebrated artifice, from Madame C.J. Walker's hair straightening techniques in the 1910s to the latest weaves embracing every style and colour, which are used openly by such singers as Janet Jackson and Christina Aguilera. This is apparent in white culture too – an improvement on nature by sporting the obviously fake can be seen in its most extreme form in the huge wigs worn by country and western singers Dolly Parton and Tammy Wynette. These are women performing femininity.

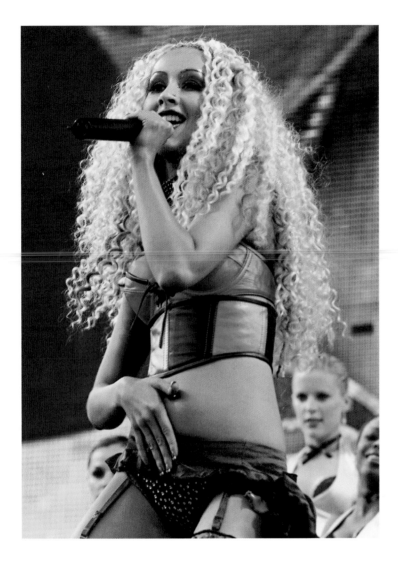

There have been important moments when embracing the fake has affected catwalk fashion. In the early 1980s the New Romantic look, which emanated from London clubs such as Billy's, and was documented in the pages of *Blitz* magazine and *The Face*, incorporated tribal prints from Vivienne Westwood, suits based on the Regency fop from Scott Crolla and bobtails by Simon Forbes of Antenna. Bobtails, sported by singer Marilyn and Hayzee Fantazee's Jeremy and Kate Garner, were artificial dreadlocks woven into natural hair and then bound up with rags to create a white Rastafarian-meets-Dickensian-urchin look. Perhaps the boldest exponent of this style was Boy George of Culture Club whom journalist Dylan Jones described as 'never a white Rasta, more a sartorial jigsaw puzzle'.[61] George's riposte? 'Basically I wear dreadlocks to annoy people.'[62] By the 1990s a

above

Using techniques from black hairdressing practice, singer Christina Aguilera supplements her own hair with waist-length extensions. (2001)

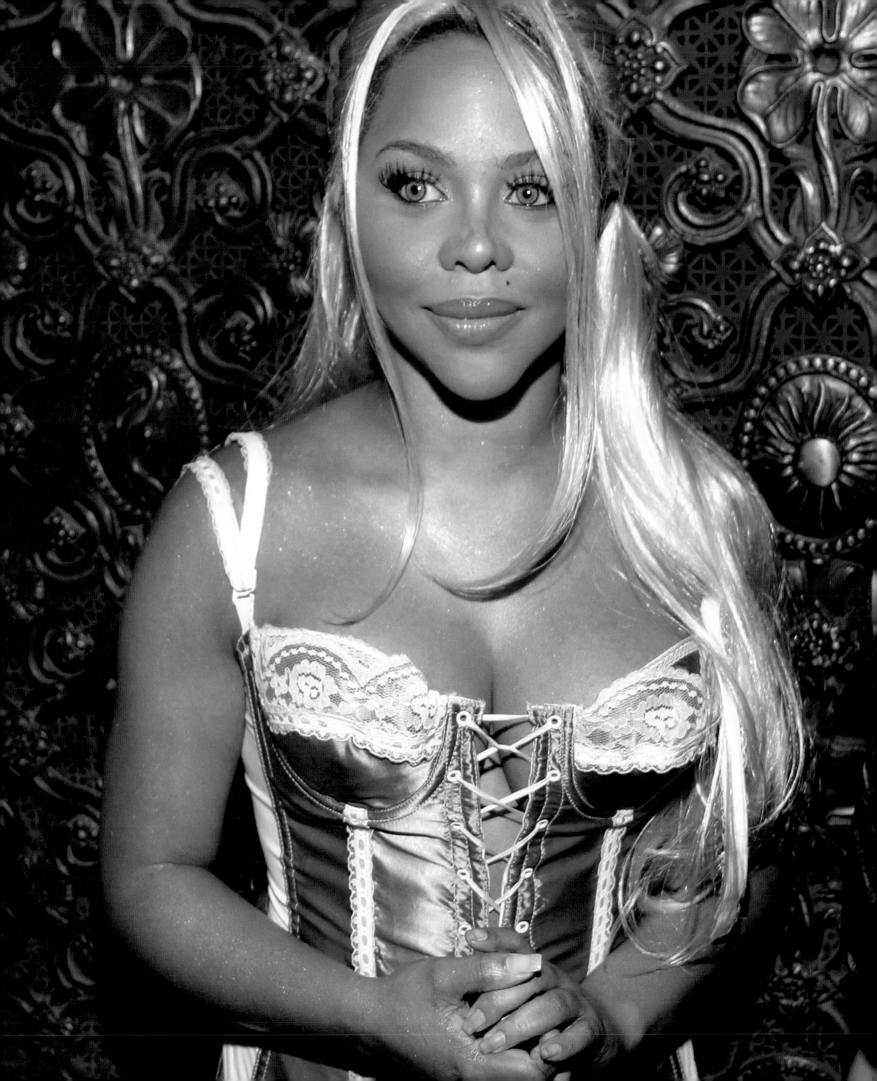

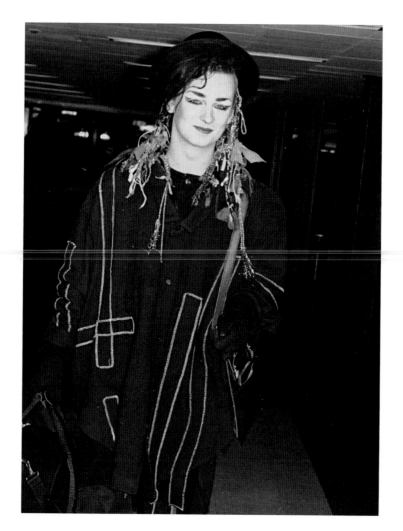

left
**Boy George began the white
crossover into Rastafarian culture
in the early 1980s with his false
dreadlocks, which came courtesy of
Simon Forbes at Antenna, London.**
(1983)

opposite
**Singer Lil' Kim is as well known
for her appearance as her music
and unashamedly embraces the
artificial with her platinum
blonde hair extensions.** (2004)

super-feminine look went mainstream in both black and white culture with overtly synthetic stars such as Pamela Anderson and Lil' Kim parading silicone-enhanced breasts, French-manicured false nails and voluminous platinum-blonde hair extensions. Gianni Versace dressed superbabes in sequinned, figure-hugging dresses split to the thigh and a new generation of British-based designers spearheaded by Julien Macdonald and Matthew Williamson played with this starlet-cum-hooker look. Nowadays fake hair is accepted in the same way as the fakery of cosmetic surgery. The boundaries of the body have been extended to almost cyborg proportions. Ironically, as we celebrate the natural, obsessing over the quality of the organic food we eat, desperate not to poison ourselves with a cocktail of chemicals on the inside, many of us are prepared to supplement our external bodies with the blatantly artificial.

She's a model and she's looking good
The Model, Kraftwerk, 1978

chapter six: Catwalk

Hairstyles invented for the catwalk have a special resonance – they are fleeting apparitions, lasting literally a few hours unless captured on film or in photographs. Nathalie Khan, in one of the few theoretical writings on catwalk shows, describes them as 'ritualised, frozen moments, aesthetic performances severed from reality in which not just designers but photographers, models, fashion journalists, make-up artists, and celebrity guests are quintessential components.'[63]

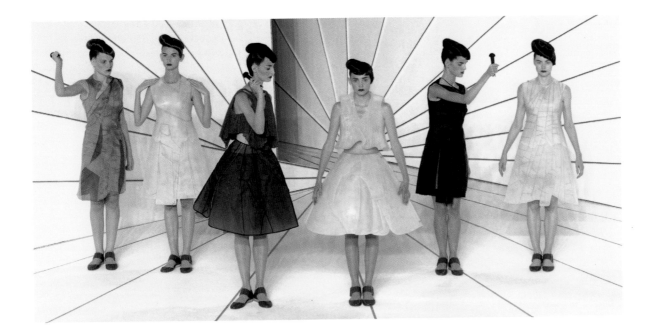

above

**Hussein Chalayan merges dress
with fine art and architecture to
create cutting-edge conceptual
fashion that perfectly complements
the graphic hair design of stylist
Eugene Souleiman, with its
echoes of garden topiary.**

(Spring/Summer 2001)

One quintessential component is missing from that list,
however – the hairstylist. The names of many catwalk
hairstylists are unfamiliar to the general public, although they
are eulogized in the industry. In the symbiotic collaboration
between fashion designers and hairstylist, the hairstylist – or
session stylist, as they are more commonly known – is a key
part in the construction of the look.

Hair contributes enormously to final runway look – who could
imagine Zandra Rhodes' 1970s creations without the
collaborative hair design of Trevor Sorbie? The same goes for
Hussein Chalayan and stylist Eugene Souleiman today. The
conceptualism of Chalayan is mirrored in Souleiman's hair for
the catwalk, which is scraped tight to the head to explode
in a puffball of texture and volume, like some bizarrely
beautiful garden topiary.

Up until the 1960s catwalk hair followed its own logic, and its
traditions were very much determined by the nature of
modelling itself. Fashion shows in the late 1950s presented
models on the catwalk wearing orthodox hairstyles comprised

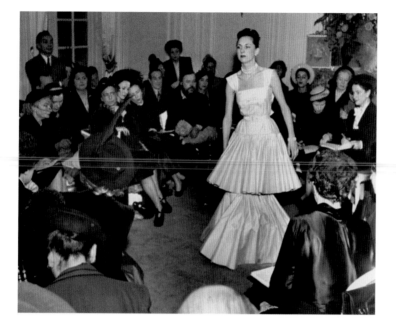

of neat chignons, which adhered to the strict rules laid down by couturiers for the presentation of their clothes. Dior and Balenciaga, for instance, always demanded the chignon – a simple, elegant style that had survived for decades as it perfectly complemented haute couture and didn't detract from the purpose of fashion shows, which was to sell clothes. Valerie Thurlow, who modelled for Balmain in Paris in the 1950s and 1960s, described spending 'the entire morning on my appearance, fixing my long blonde hair into an elaborately simple chignon,'[64] and Jean Dawnay, who worked for Dior and Balenciaga, described a model at her first audition with 'her hair drawn back so tightly in a bun it gave her face a Chinese look.'[65] If shorter styles were required, hairdressers shaped and cut wigs for models – or more importantly, their agencies, who didn't want any kind of radical cut as they believed it would limit any job opportunities. Most of the time, however, models styled their own hair for shows. As Jean Dawnay explained, 'models became very expert at changing their hair halfway through a show, or for pictures, sleeking it back with lacquer and pins or bringing it forward into a bob,'[66] and Anne Gunning, another model, complained that 'there was no time for parties at night

above left

A Paris couture show for Christian Dior in 1947. The model's hair is in a simple chignon so as not to detract from the extravagant cut and silhouette of the gown.

above right

Model Dorian Leigh dressed in Dior with her hair in a chignon. Simple upswept hair was de rigueur **for shows and shoots in the 1950s.**
(1950)

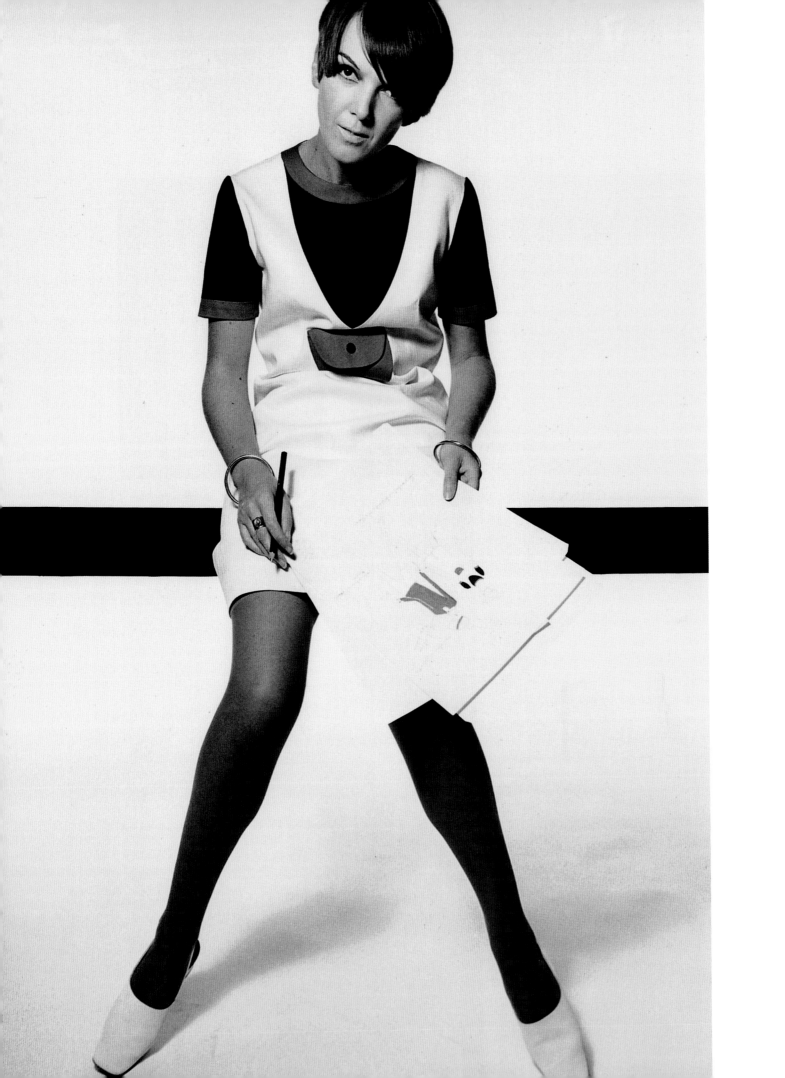

because I would be up at five in the morning and come back absolutely exhausted, having to prepare my accessories and re-set my hairpieces for the next day's work.'[67]

With the partnership of Vidal Sassoon and Mary Quant, however, this mould was broken and the session stylist was born. One of the first designers to grasp the vital link between hair and fashion, Sassoon saw the role of hair as setting trends rather than following them, creating rather than aping looks on the catwalk. In the 1960s he saw key changes in culture: 'Around me I could see clothes that had a wonderful shape to them and all because of the cutting. I wanted to see hair keeping up with fashion, maybe jumping ahead of it, leading it along a certain line, instead of lagging behind it. I wanted to shape heads, as the new, young fashion designers were shaping bodies. I wanted to cut hair as they cut cloth. I wanted to be in on the revolution that was simmering.'[68] Mary Quant had expressed a similar dissatisfaction with the traditional way of showing a model's hair: 'I'm sick to death of all those chignons we've been using at the shows. I know we can't have hair hanging down over the model's shoulders, but surely there is some other way to keep it away from the clothes rather than making it climb up the back of the head like ivy.'[69] Sassoon suggested cutting it all off, and at Quant's show the model Grace Coddington was the first to appear sporting the now famous 'Five Point cut'. He remembers: 'I sat at the back of the room among some of the world's most important fashion writers, who had come to see Mary's clothes after weeks in the classically orthodox atmosphere of the Paris couture houses. Grace... swung into view. As she danced before them, her hair danced with her clothes and there was a gasp from the audience. She disappeared and the room buzzed with whispered comments.'[70]

Before the early 1960s, hair bore no real no correlation to the outfits in the shoot or show, and as hairdressers tended to do the models' hair for free because of the publicity it afforded the

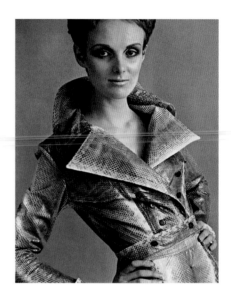

above

Model Grace Coddington was one of the style leaders of the 1960s, able to morph from one iconic look to another, devising a fashion vocabulary used to full effect today in her role as Creative Director for Vogue. (1967)

opposite

With the rise of young new designers such as Mary Quant in the 1960s, hair had to change to fit in with the image of modernity and leave behind old-guard couturiers of Paris.

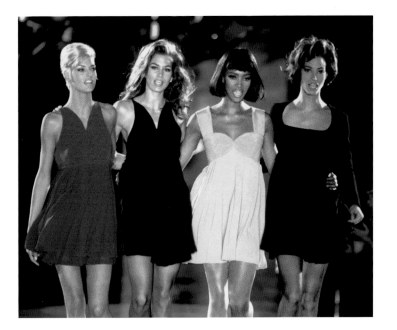

above

The four key supermodels of the 1980s and early 1990s: Linda Evangelista, Cindy Crawford, Naomi Campbell and Christy Turlington. Evangelista had appeared blonde for the first time in George Michael's 'Freedom' video. (1992)

salon, styles tended to follow the dictates of the photographer. Gradually model agencies began to realize that a signature hairstyle could launch a new face or reposition an older one. Valerie Thurlow was one of the first to change her hair dramatically: 'I decided to have my hair cut in a really "with it" style... short at the back and level with my chin in front, and with a straight fringe down to my eyebrows. I felt quite different with it this way round and found it perfectly natural to slip into the droopy, helpless, rather gormless pose that was all the rage.'[71]

More recently, in 1991, the photographer Steven Meisel persuaded Linda Evangelista to go blonde and her appearance in the George Michael video 'Freedom' led to a blonde trend amongst catwalk models such as Kate Moss, Carla Bruni and Nadja Auermann. Evangelista's blonde hair, which was created by Benjamin Forest, had its own 'trickle-down' effect: there was a subsequent marked increase in salon colouring and Donatella Versace, no stranger herself to peroxide, launched her 'Blonde' fragrance in 1995. Guido Palau's cut for model Erin O'Connor was yet another catwalk transformation in 1998: 'She had a plain

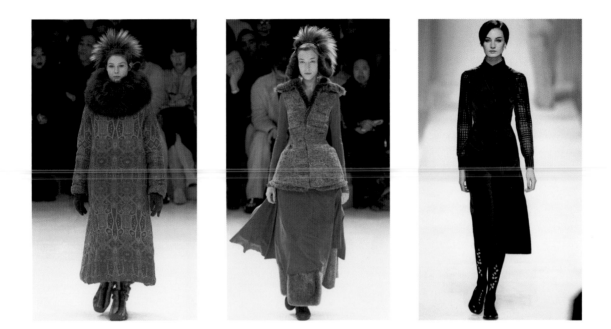

bob and wasn't getting quite enough work. I advised her to go extreme, and shaved off some of her hair, undercut it and dyed it black... models should be brave.'[72]

The 1970s and 1980s saw the rise of session stylists and Liz Tilberis recalled that, in the early 1970s, 'I noticed right away that the coolest guy on our sittings – the one who people hung around, listened to and worshipped – was the hairdresser. Everybody would wait for the hairdresser to act.'[73] The job of session stylist had become what Tilberis described as 'a specialised art form and a career path. No longer was the hairstylist always the same guy who worked in the salon.'[74] Radical catwalk relationships were fused between Trevor Sorbie and Zandra Rhodes, Ray Allington and John Galliano, Christiaan and Yohji Yamamoto. Christiaan, a Dutch session stylist, was a fashion innovator responsible for singer Grace Jones' flat top and inventor of the buzz cut, where the hair was shaved on the sides but longer on the crown and left to flop over the top – a look that dominated subcultural fashion in the mid-1980s. In his collaborations with the New York designer Stephen Sprouse, he married synthetic hair with Sprouse's synthetic fabrics in neon

above left and centre
Yohji Yamamoto's Autumn/Winter 2000 collection featured clothes inspired by an arctic winter. Stylist Eugene Souleiman used hairpieces that framed the head in huge feathered fan shapes. The rough, undone look followed the show's concept of nomads existing on an icy tundra using whatever came to hand to cover their bodies.

above right
Erin O'Connor sporting a striking crop with undercut, a technique originally used in 1930s barbering. The undercut was re-invented by Dutch session stylist Christiaan and dominated alternative hairdressing in the early 1980s.
(Autumn/Winter 2000)

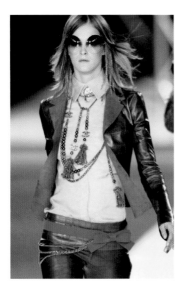

above left

Catwalk hair has to add to the total look without proving too much of a distraction from the garments. For Chanel Autumn/Winter 2002, Odile Gilbert created a layered look with a '70s edge that referenced the collection's key inspiration.

above right

Blurring the boundaries of masculinity and femininity this contemporary androgynous look, again by Odile Gilbert for Chanel, shows the sophisticated subversion of catwalk hair today.

opposite

McQueen, like his contemporary John Galliano, mixes historical and contemporary references to create powerful catwalk images of femininity in which the hair design perfectly complements the clothing.
(Autumn/Winter 1999)

hues and graphic prints, using post-war American history as his source rather than deferring to European influences. Sprouse acknowledged Christiaan's input by describing him as 'a crucial individual in my life.'[75] Julien d'Ys, the French session stylist, produced some of the most conceptual, experimental catwalk looks in the 1980s, particularly in his work for Karl Lagerfeld. His historicist approach and redefinition of classic hairstyles, pastiching the signifiers of 'Chanel-ness', were a perfect match for Lagerfeld's rejuvenation of the classic Chanel look – gilt buttons, chains and pearls and the double C logo. A similar strategy was adopted by Odile Gilbert, who reworked the classic Chanel neck chain into kinetic hair jewellery in 2002.

By the 1990s session stylists had superstar status in their own right rather than being associated with famous clients or products, and worked entirely on the catwalk or on photo shoots rather than in the more commercial areas of the trade. Their situation regarding a model's image was very similar to the 1950s – it was very difficult to give them a radical cut. As Eugene Souleiman puts it: 'You can't just cut off a model's hair for a show, because one day she is doing the Gucci campaign,

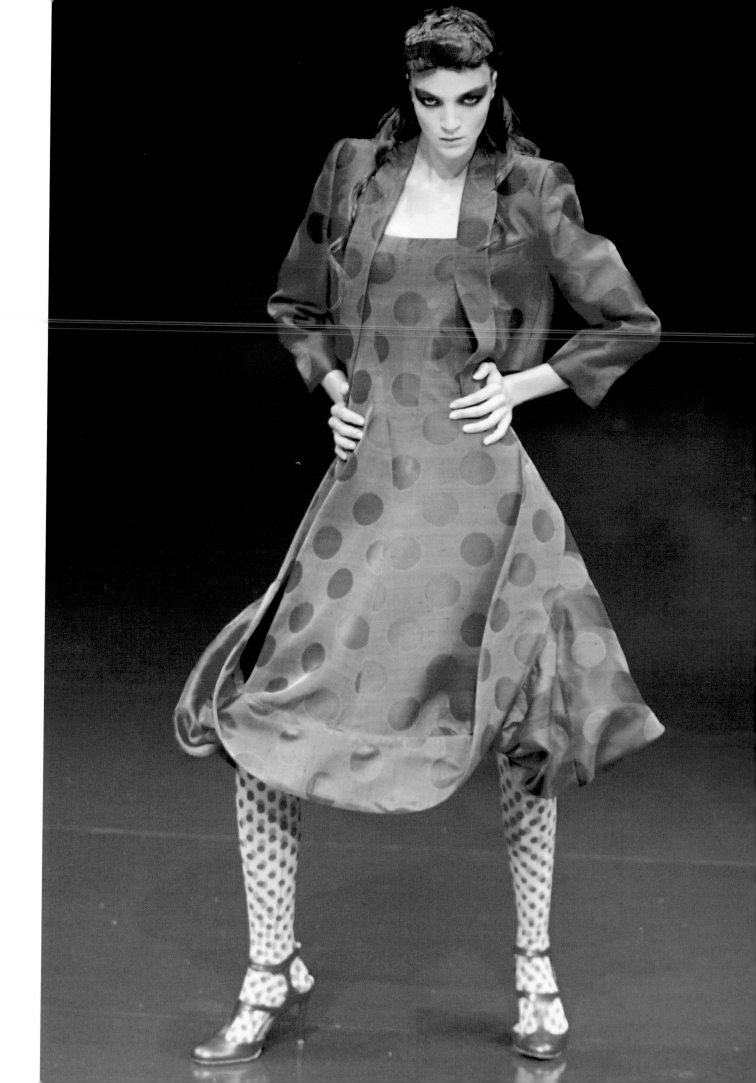

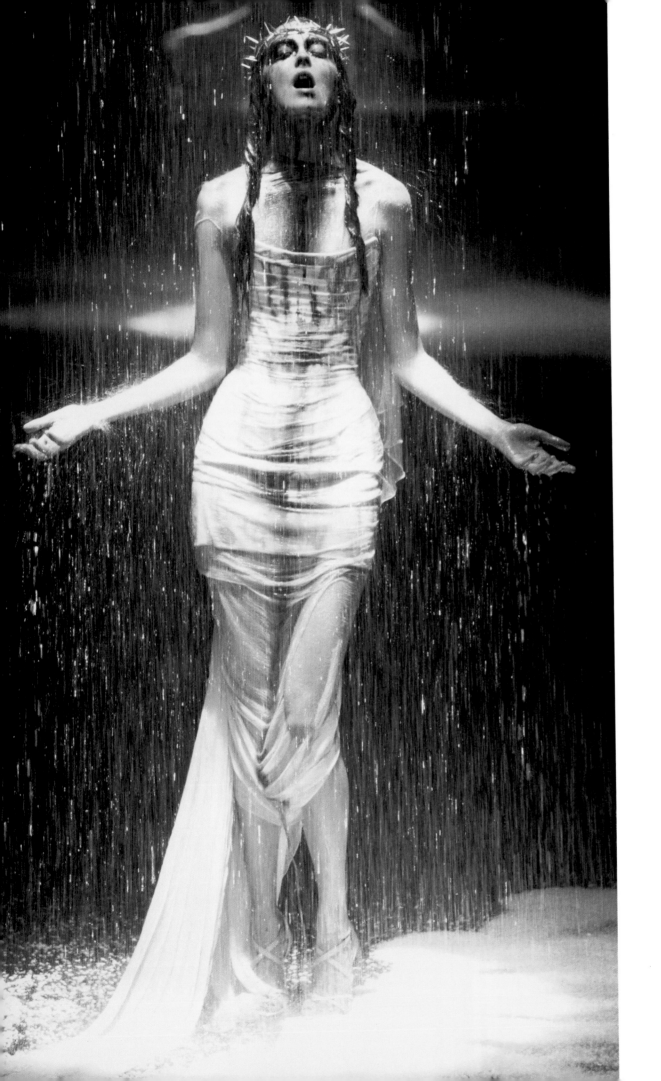

and the next it's Jil Sander. Now we have to make a statement in fashion without cutting their hair. So I simulate or use things that are symbolic of hair. I've been using a lot of feathers.'[76]

Guido Palau is famed for his collaborations with the photographer David Sims and designer Calvin Klein, and his cutting-edge work appears in *The Face*, *Vogue* and *Harper's Bazaar*. Enormously influential from the 1990s on, he advocates the imperfect and unstructured hairdo that accentuates imperfection and idiosyncrasy, triggering a reaction against the slick, salon styles that have dominated mainstream fashion work. It's a new aesthetic used in its most profound way in the bald, bleached and braided looks of the catwalk shows of Alexander McQueen and originally inspired by a New-Age traveller he had spotted in Camden. His influences often emanate from the street and its ever-shifting subversions of beauty: 'It's about looking again at imperfection and finding beauty in it as a way of expanding definitions... after a year or so the ideas become mainstream on a scale we never expected. Looks that have been ignored are being brought into the mainstream where they can transform definitions of beauty. In my own area, I was showing different types of hair on different men and women and saying: look, all this hair is beautiful and it is all relevant. I would ask myself, why is something imperfect? The truthful answer is we do not really know. Is lank, flat hair imperfect because someone said that glossy, big hair is perfect?'[77]

Palau's contemporary, Orlando Pita, has executed incredible catwalk hair for John Galliano's shows, covering all extremes from the braided warrior Mohawks of 1999, a triumph of technical execution, to the high-stacked hair of 2004's Nefertiti-inspired collection featuring gilded snakeskin, coral organza and tulle dresses covered in sumptuous gold embroidery. His long hippie extensions for Gucci contrast with his more avant-garde work for Galliano, which in 2002

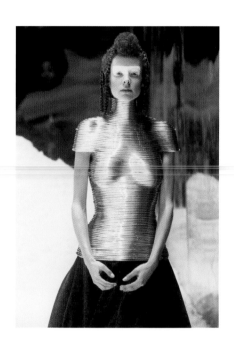

above
Alexander McQueen's Autumn/ Winter collection of 1999 recreated a frozen tundra in the Arctic and featured parkas mixed with puffball skirts and Edwardian frock coats. Here Shaun Leane's silver coil corset is mixed with Guido Palau's braided and backcombed hair design, a look which fuses nostalgia with the contemporary.

opposite
Alexander McQueen's 'Black' fashion show featured highlights from his past collections, including this show-stopper: the crown of thorns headdress worn over coils of dark hair a contemporary interpretation of the Christ figure. (2004)

above

John Galliano's Spring/Summer 2004 collection was inspired by his visit to Cairo and Luxor, and used hieroglyphic prints on column dresses together with headdresses and masks evoking the reigns of Nefertiti and Tutankhamun by milliner Stephen Jones. In the same collection stylist Orlando Pita created high-stacked hair to match the extravagance of the gowns fashioned out of gilded snakeskin, coral organza and embroidered tulle.

opposite

McQueen has presented many versions of femininity in his catwalk shows. This one is more softly romantic, almost Pre-Raphaelite in conception, and is complemented by a softly curled and textured hair design. (Spring/Summer 2004)

incorporated tribal braids, cornrows, 1950s chignons and Mongolian fur, and all in one runway show – a typical Galliano world-culture mix. Odile Gilbert mixed wildly teased hair with heavy black eye make-up in one Galliano show, melding the Hollywood sophistication of Marlene Dietrich with grunge goddess Courtney Love (Autumn/Winter 2003).

So it's not just the clothes that make or break a show. Catwalk hair design may seem very far removed from reality but however baroque the theatrical display, very often a show contributes to the changing way we view fashion and the way we are going to be viewing fashion in the very near future. Hair on the catwalk may seem to defy logic but trends filter down from catwalk to sidewalk, helping us to reassess notions of contemporary beauty.

Just hanging around. Looking sharp. Making history.[78]
Ted Polhemus

chapter seven: Street

Haircuts can be acts of rebellion, stemming from the teenage need to be individual, to look different from the preceding generation and to show disquiet at adult rule. From these small gestures of independence whole fashions can grow – some of the most influential looks have been inspired by the street. The teddy boy with a greased quiff, drape suit and a pair of knuckle-dusters sauntered the streets of London's East End as a living embodiment of teenage cool. Inspired by the black American

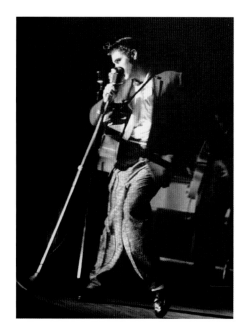

'conk', white teenagers contorted their hair into greasy quiffs using Brylcreem and a comb. They may have had no real power over their education, jobs or prospects but teds were in control of their appearance and could therefore stand out from the crowd. Many spent their hard-earned income on tailormade drape suits with long jackets, drainpipe trousers and crêpe-soled brothel-creeper shoes. American actor Tony Curtis provided inspiration. His curly greased fringe, pure 1950s, was worn for all his roles – even period parts such as a Roman slave in *Spartacus* (1960). He describes the origins of his seminal look: 'It all began when I couldn't afford a haircut. Then I thought my gift was so mystical and magical that by cutting my hair I could be gone. I could understand what Samson felt.'[79] Elvis Presley loved the Curtis cut, and using Royal Crown pomade and L'Oréal Excellence Blue-Black dye created one of the most iconic hairstyles of the twentieth century.

It could be difficult for many embryonic teds to achieve exactly the right quiff as it was so outside the parameters of mainstream fashion for men. Writer Ray Gosling remembers the battle to achieve the quiff in Nottingham: 'Most stylists, or

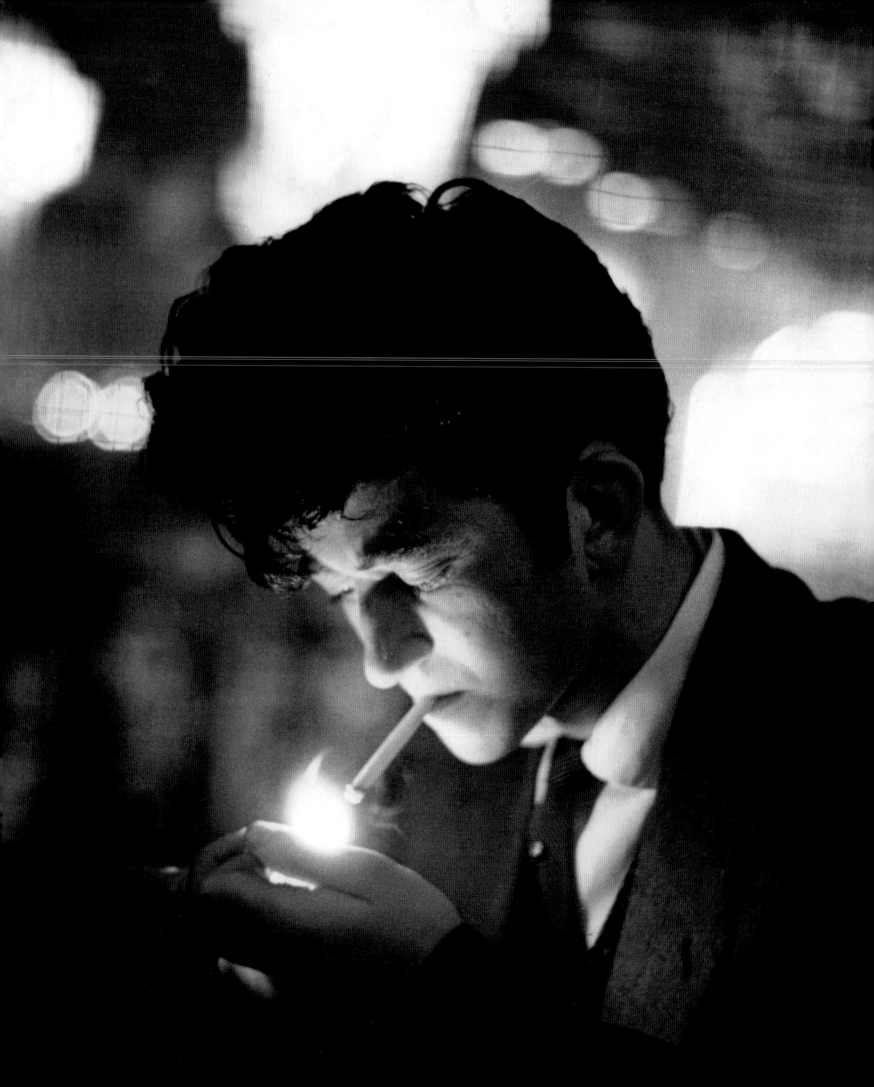

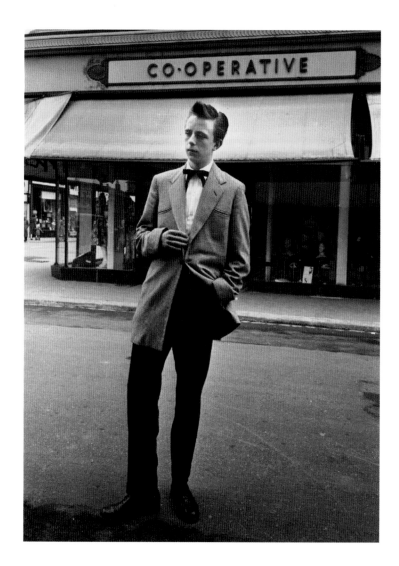

right

A London teddy boy in the street uniform of drape suit, 'western' tie and quiff styled with Brylcreem. Teds were the first independently recognized mass British youth culture and had a reputation for delinquency. (1954)

barbers as they were called in those days, were men who had been wounded in the war and they cut short-back-and-sides with conviction – but a barber called Wally began to specialize in styling teds' hair. He was a good cutter, serious, and your front quiff he would curl with hot irons. You'd then be finished off in front of a dryer with a hairnet on, feeling silly and cissy. Wally'd give you a final blow, a last flick and it was beautiful when you went out. We used to plaster it with coconut grease from Boots the Chemist: thick grease. I remember a cold day when it was freezing and I couldn't move my hair at all and had to get near a coal boiler to warm it up 'cause the grease had all frozen. Solid coconut grease. When it was hot weather it melted and ran down the back of the neck, spoiling your nice white shirt, but we wanted our hair to look greasy, not clean.'[80] Girls were

 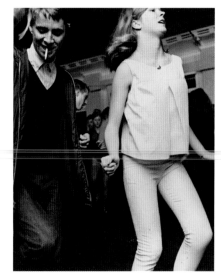

not exempt from the quiff either. One English teddy girl of 1959 wore 'a white "scooter" or "autograph" jacket, so called because one always hoped someone famous would sign them. They were only made of white plastic but I thought I was really hip in mine. I had a black pencil skirt with a slit up the back to show a bit of leg, and a spotted cotton blouse that cost me 4s and 6d. My lipstick cost 1s and 6d and was called something like Frosted Pink. It was so pale it made me look ill, but it was all the rage so I wore it. My hair was cut in a DA, and to complete the outfit I wore black slip-on shoes and luminous lime green or orange socks.'[81]

The greasy look was completely overturned by the mods of the early 1960s. Continental cuts were adopted by these fashion fetishists who in their obsessive search for style ignited the phenomenon of Carnaby Street. Here John Stephen, one of London's most fabulous fashion entrepreneurs, fed his mod audiences the latest in Italian tailoring. Tonic suits with three-button shortened jackets and close-fitting trousers were items 'of exquisite refinement, where the size and placement of a button and the width of a lapel were subjects of lengthy

above left

Mods were fashion fetishists obsessed with the length of a jacket and the width of a lapel. They ignored the greasy look of '50s hair in favour of grease-free Continental cuts. (c.1960s)

above right

A male mod with a Nero haircut, a look still popular today, dances with a Chelsea girl obviously inspired by model Jean Shrimpton. (1963)

above right

Mods had a variety of hairstyles from the short cropped Nero (far left) to the fuller backcombed 'rooster' cut (far right). The fashionable masculinity of this look has meant that it has been consistently revived since the 1960s. (1964)

negotiation with the tailor.'[82] Subverting the British 'county' style of tailored suits in mohair or houndstooth check, male mods prided themselves on their sartorial elegance. Cecil Gee suits, Caesar haircuts and popped purple hearts were the order of the day for a lifestyle that revolved around the hedonism of consumption. Girls wore the most up-to-date of fashions – beehive hairdos and Italian winklepickers. The Dean was the ace face, the perfect mod: 'College-boy smooth crop hair with burned-in parting, neat white Italian rounded-collared shirt, short Roman jacket very tailored (two little vents, three buttons), no turn-up narrow trousers with seventeen inch bottoms absolute maximum, pointed toe shoes, and a white mac folded by his side.'[83] Inspired by the Italian mania that had reached Britain from the Continent in the shape of the Lambretta scooter, stiletto heel and cappuccino coffee bars, mods adopted a neat sharp look of expensively tailored suits with bum-freezer jackets, John Stephen shirts and straight-cut trousers for boys and Pucci prints and Quant pinafore dresses for girls. Cuts were short and most importantly grease-free, and this new mode of hairdessing was dubbed 'dry cutting' or 'continental'. Mod girls went for the geometric looks of

above

The Sex Pistols. From left to right: Steve Jones, Johnny Rotten (John Lydon), Glen Matlock and Paul Cook. The influence of punk is still felt, most conspicuously in the sound and style of such bands as The Libertines, The Hives and Sum 41. (1976)

Sassoon, boys wore the brushed forward 'Nero' or backcombed 'rooster' cut. Richard Barnes remembers: 'Special "bobble combs" for backcombing became standard equipment and guys started lacquering hair to keep it in position. Hair could be raised two or thee inches with practice, effort and a backcomb. Rod Stewart had the most far-out backcombed hair I ever saw. His hair was longer than most Mods, and it rose up from just in front of his crown to it seemed about six inches in height and was heavily lacquered.'[84] A taste for fashion was no longer about being expensive and elite but was part of a new populist consumer culture which demanded design that was modern, a move away from the stuffiness of Parisian haute couture that had been strengthened by the death of Christian Dior in 1957. Styles were coming from the street and the new mod look was to dominate fashion in the 1960s, until that in turn was supplanted by the 'free love' look of the hippies. For teenagers Italian fashion was chic and modern, everything the post-war Britain of their parents was not, and they had the time and money to indulge themselves during years of almost full employment and economic boom.

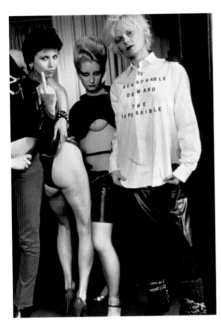

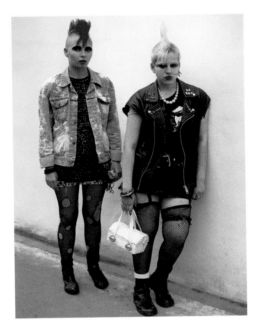

above left

Chrissie Hynde, lead singer of The Pretenders, Vivienne Westwood and sales assistant Jordan pose inside the World's End shop, Sex, in the mid-1970s. The use of overtly sexual references in Westwood's designs defined the look of early punk. (1976)

above right

By the early 1980s the punk look was as immediately recognizable as any other London tourist attraction. The shock of girls dressing like prostitutes had lessened over time and was diluted by its acceptance into mainstream fashion. (1983)

Styles from the street were to dominate the mid-1970s and early 1980s with the emergence of punk. The natural Californian blonde flick of Farrah Fawcett-Majors was rejected by the punk girl in favour of a vertically styled shock of hair dyed in iridescent colours, or the bleached white, black-eared feline cut of Sue Catwoman. Jordan, one of the key faces of punk, worked at Sex, the boutique at World's End, Chelsea, owned by designers Vivienne Westwood and Malcolm McLaren. Wearing clothes based on the sado-masochistic garments of pornographic fetishism, Jordan cut a fearful sight. Boy George remembers that going through the doors of Sex was like 'entering the waters of a freezing pool. Jordan the psycho-hived manageress, was every bit as intimidating as the premises, a small dark shop with sloping wooden floor and blacked-out windows. She dressed like a sadistic Tiller girl, carried a whip and hissed at customers.'[85] Punk used the language of the cheap and trashy: an Acme Attractions 'fluffy fake fur jumper with plastic see-through breast panels, rubber tops and trousers... tight black T-shirts with zips across the nipples, Westwood tartan bondage trousers and high black stiletto boots.'[86] Many punks rejected the Westwood designer look,

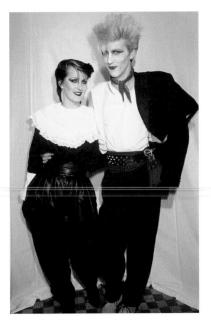

opting for a DIY style – Millet's army surplus store for straight leg trousers and painter's overalls and retro finds from the local Oxfam shop. Achieving the vertical hairdo was difficult before the advent of mousses and gels, so punks used anything that came to hand – flour and water, even Uhu glue. One punk remembered the effects of experimentation: 'I spiked my hair with a mixture of sugar and water, it worked really well and I really looked the part, pretty outrageous I thought. However, I didn't take into account that it was a warm summer's day. My head turned into a huge sticky mess and nobody would come near me because I was surrounded by a massive swarm of flies.'[87]

Punk's DIY approach to fashion was taken to its extreme with the New Romantic movement, which in the main was centred on London clubs in the late 1970s. Club promoters such as Steve Strange and the eccentric Philip Sallon, who wore an Egyptian collar with a black velvet skirt and lacquered his hair into devil's horns, raided history for every style imaginable to assemble a theatrical cross-dressed look that was exuberant, camp and colourful. Its fashion equivalent could be seen in

above left

The New Romantic movement, which had grown up in the clubs of Birmingham, Sheffield and London, was a direct antithesis to the dressed-down look of punk. Eschewing mundane dress, New Romantics at Billy's or the Club for Heroes wore a mix of theatrical dress, vintage and DIY. (1981)

above right

Adam Ant moved the New Romantic look into the mainstream with his blend of vintage and designer fashion and his romantic curled and braided hair worn with warrior make-up. (1981)

Westwood's Pirate collection and the pop styles of Adam Ant and Martin Degville of Sigue Sigue Sputnik, who had an enormous blonde quiff. Boy George 'created a new look every night. My room was like backstage at the Mikado. I loved the Eastern flavour: kimonos and geisha make-up, straw hats decorated with fruit, flowers and birds, twisted up with platform shoes and a big mandarin brolly. Putting on my face was a time-consuming ritual. Foundation and powder first, then a cup of tea while it settled. My eyebrows were shaved so I could wing them in any direction. Last was always the hairpiece, hat and earrings.'[88] New tribes took to the streets showing a savvy attitude to past styles – a rockabilly quiff here (Brian Setzer of the Stray Cats had the most impressive), a zoot suit and flat top there. Model Scarlett sported a shaven head with an inverted crucifix fringe; alternatively 'it was bleached blonde and styled into the most incredible high flat top shaped into the New York skyline. She dressed in very stylish clothes that were usually made for her. Grey muslin was all the rage then, and she had a very long dress that draped around her body and dragged along the floor. One of her trademarks was to wear dead chicken's feet as earrings and she was usually accompanied by Cerebus, her

above left

Perfomance artist Leigh Bowery was a marginal figure in the 1980s but his legacy has influenced designers today, in particular John Galliano and Alexander McQueen. (1980)

above right

The Human League was one of the most successful electro bands of the 1980s, and lead singer Phil Oakey had one of the greatest rock hairstyles. His mutant wedge cut had a shoulder-length asymmetrical fringe. (1981)

opposite

Brian Setzer of the Stray Cats wore a blonde quiff and kickstarted a whole new subgenre of rock and roll, the psychobilly. Psychobillies took 1950s styling to the extreme with towering hair and brash retro clothing. (1989)

Nirvana frontman Kurt Cobain with a hairstyle synonymous with 'grunge', a Seattle-based music style that became a global phenomenon in the 1990s and was a precursor of the current 'Nu metal' scene. (1993)

crippled dog.'[89] Singer Phil Oakey, front man of the Human League, had a mutant asymmetrical wedge, one side chin-length, the other cut to the ear. Leigh Bowery, performance artist and promoter of Taboo, the legendary nightclub, was the most outrageous, wearing a blonde bob in 1980 and then in 1985 shaving his head and turning his bald pate into a canvas. Friend Sue Tilley remembers that 'he decided to put drips of paint on his head and changed the colour of them to match what he was wearing. He loved the fact that at the end of the night you could just peel the drips off in one fell swoop.'[90] Perhaps in reaction to all this decadence, ravers in the mid 1980s dressed down with a look that was far more anonymous, using 'smiley' T-shirts and tie-dye, denim flares and hooded tops, and adopting what was dubbed the 'Madchester bob', 'Baldrick' or 'wings' haircut – later worn by David Beckham in his early footballing career. In the US the grunge scene based in Seattle popularized a dressed-down look, with jeans, workshirts, heavy boots and deliberately unstyled hair. Kurt Cobain, lead singer of über-grunge band Nirvana, brought a thrift store sensibility to his anti-image: 'for Saturday Night Live he wore the same clothes from the previous two days: a pair of Converse tennis shoes, jeans with big holes in

the knees, a T-shirt advertising an obscure band, and a Mister Rogers-style cardigan sweater. He hadn't washed his hair for a week, but had dyed it with Strawberry Kool-Aid, which made his blonde locks look like they'd been matted with dried blood.'[91] New Age travellers took a similar stance against social control with matted, tangled dreadlocks woven with beads and braids, forging a countercultural alliance with ravers and festival goers against the Conservative government's transport programme.

In complete contrast, hip-hop, imported fresh from the streets of New York's Bronx, advocated a dressed-up rather than dressed-down style, which had taken over the sidewalks of most major cities in the globe by the early 2000s. Designer sportswear, name trainers and bling have become a mainstream fashion that few refuse to buy into, whether black or white. Original b-boy haircuts used razoring and shaving techniques to cut logos into the back of the head – the Nike swoosh was a favourite; now French crops and natty dreads have been incorporated into the look, which shows no sign of flagging. Hip-hop illustrates the power of streetstyle, once the preserve of the heroic few, now worn by millions and wielding more power than any season's catwalk chic.

above

Popular with both modern hip-hop and drum-and-bass stars of the early 1990s, razoring techniques were employed to create a variety of designs – most notably the Nike swoosh or VW car logo. Originally razoring was used in New York to tag gang members.
(1990)

Would ya just watch the hair. Y'know I worked on the hair a long time, and he hits it! He hits my hair!
Tony Manero in *Saturday Night Fever,* 1977

chapter eight: Celebrity

In our culture, celebrities are worshipped; their perfect faces stare out from the covers of magazines, which are filled with gossip about their private lives. We try our best to ape their clothes and looks, and for many of us the easiest aspect to copy is their hair; taking on the cut of a star has a transformative power that sustains this feeling of identification long after the film or TV show has finished. Entering the salon with a photo of a star ripped from the pages of a glossy magazine

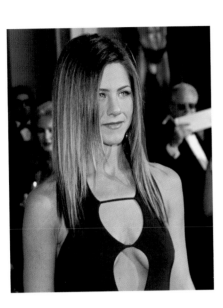

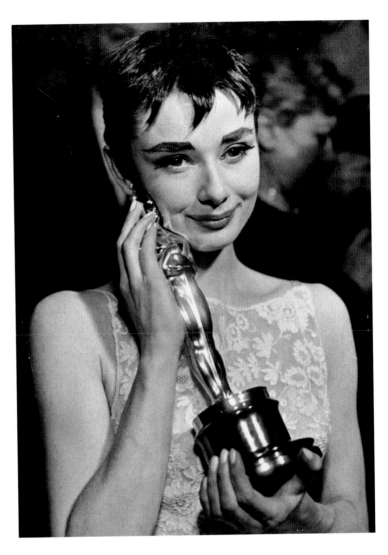

above left
Jennifer Aniston's mid-length layered and flicked 'Rachel cut' of the 1990s was one of the most copied looks of the decade. Her longer ironed hair of the early 2000s was equally iconic. (2003)

above right
Audrey Hepburn wins an Oscar in 1954 and sports her gamine cut which became a popular Bohemian style for young women in the mid-1950s, a youthful counter to the more mainstream bouffant.

is a rite of passage for many teenagers and has been ever since the existence of the star system in Hollywood. In the 1950s it was Audrey Hepburn's gamine cut as worn in *Roman Holiday* (1953); in the 1990s the 'Rachel cut', as worn by Jennifer Aniston in *Friends*, won global popularity; and in the 2000s David Beckham's every change of hairstyle is anticipated with bated breath.

The development of the cinema in the 1930s and 1940s set stars out on display in the same way as the latest fashions could be seen in the magically lit windows of department stores. Hortense Powdermaker, one of the first to investigate the machinations of Hollywood in *The Dream Factory*, wrote: 'The star has tangible features which can be advertised and marketed

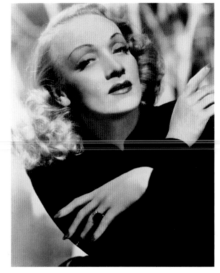

— a face, a body, a pair of legs, a voice, a certain kind of personality, real or synthetic — and can be typed as the wicked villain, the honest hero, the fatal siren, the sweet young girl, the neurotic woman.'[92] Bette Davis, who cornered the market in the neurotic in the 1930s and 1940s, demonstrated the transformative powers of fashion in her seminal film *Now Voyager* (1942). A spinster at the start, Davis finds love by ridding herself of thick glasses and fashioning her hair into a glamorous upswept do — implying that any Plain Jane could find love with the help of the right beauty products.

Going to the cinema was a magical experience in the 1930s — with the Wall Street Crash of 1929, the Depression and the rise of fascism in Europe, it provided a much-needed channel of escape. Here was an alternative world of glamour peopled by stars such as Shirley Temple, Errol Flynn, James Cagney and sexual sophisticates Greta Garbo and Marlene Dietrich. One fan admitted: 'An ultra-glamorous star was an awesome sight for us gangly girls. A sight to behold in our minds. We were transported to a fantasy land where we were the screen movie queens.'[93] Movie stars' images were consumed so avidly that

above left

Bette Davis was one of the most successful actresses in Hollywood in the 1930s and 1940s. Her chic, bandbox neat appearance was as much copied as her rolled and set hairdo. (1946)

above right

Former cabaret singer turned actress Marlene Dietrich kept a diva's control over her perfectly coiffed hair. In the oasis scenes for The Garden of Allah **(1936) the wind blows the trees but her hair never ruffles.** (c.1940s)

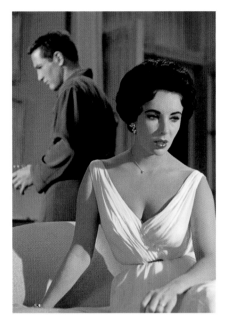

above

Actress Elizabeth Taylor epitomised 1950s film-star glamour with styled and set hair by Sydney Guillaroff who worked alongside her on many of her most famous films.

right

Jayne Mansfield embodied the dumb blonde stereotype of the 1950s, with starring roles that cast her as a perennially sexy platinum blonde in high heels, tight sweaters and leopardskin. (1956)

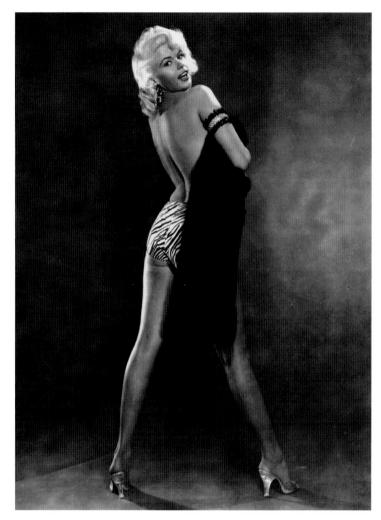

those in the public eye needed to be conscious of their looks at all times. Silent screen star Mary Pickford thought long and hard about cutting off her trademark long ringlets in the 1920s – the height of the craze for the bob. Eventually she succumbed, and her career went into freefall. Veronica Lake's peekaboo fringe in the 1940s was banned in munitions factories in Europe and America in case the hair became caught up in machinery. In the 1950s teenagers looked to James Dean, Marlon Brando, Marilyn Monroe and Sandra Dee, and magazines such as *Photoplay* and *Picturegoer* detailed the lavish lifestyles of the rich and famous – Jayne Mansfield pampered her heavenly body

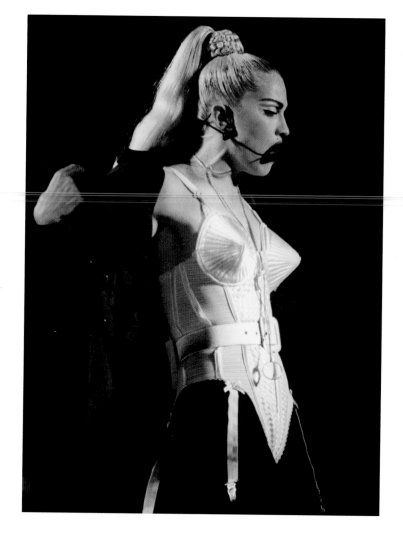

above

Diana, Princess of Wales remains in the headlines despite her untimely death in 1997, and has become the ultimate female celebrity. For most of her life in the spotlight her hair was attended to by hairdresser Sam McKnight. (1997)

left

Madonna used peroxide blonde hair combined with overtly sexual stage clothes (including the infamous breast cones) by Jean-Paul Gaultier to create a powerful female image in the 1980s and early 1990s. (1988)

in a pink heart-shaped bath and had 500 pairs of stilettos, while Diana Dors possessed a mink bikini. Elizabeth Taylor was a star of Olympian standards, described by film critic Alexander Walker as 'the most expensive, the most beautiful, and the most married and divorced, being in the world. Her love life plus her sheer expensiveness are what make her interesting, not her similarity to you or me.' [94]

Celebrities, then, are different; they possess a certain something, they are charismatic, they light up the screen, they inspire adulation – seen at its most extreme with Diana, Princess of

By the late 1970s Bryan Ferry, lead singer of Roxy Music, had gone solo and recreated himself as a sophisticated lounge singer in suits by Anthony Price and hair by Keith of Smile. (1988)

David Bowie as Aladdin Sane, his androgynous alter-ego of the 1970s, who inspired a whole generation of New Romantics in the early 1980s. His haircut by Susie Fussey was the precursor of the 1980s mullet. (1973)

Wales. Elvis Presley, too, continues to inspire love beyond the grave, while Madonna is still a role-model in her forties.

Celebrity cuts can be more extreme, however, changing fashion rather than just temporarily engaging with the latest style. Limahl of Kajagoogoo's two-tone mullet by Toni and Guy (who were credited on his record sleeves), Madonna's blonde crop, complementing her black bustier for 'Express Yourself', and Bryan Ferry of Roxy Music have all contributed to the cult of celebrity cut. From his extreme dyed black quiff styled by Keith Wainwright of Smile, worn with a blue-spangled suit with feathered shoulders, to the 'half-tamed forelock'[95] seen in 'These Foolish Things' (1973), Ferry has inspired legions of fans to follow his every sartorial move. Wearing stage outfits designed by Anthony Price, he has moved through high glam to G.I. chic and on to a classic masculine tailored look. Peter York described Ferry's image changes: 'Very clever, agonizingly fastidious, he managed to give the post-modern appearance of standing outside what he did – then a new posture – while at the same time being hyper-involved and passionate. Similarly, the looks, all of them, said that this is just a phase, just

above
English footballer Chris Waddle with a mullet haircut. Throughout the late twentieth century, footballers' hairstyles have led the way, from George Best's feather cut of the 1960s to Beckham's samurai look of 2004. (1983)

costume for now. But at the same time, it mattered enormously how you looked.'[96]

David Bowie's Ziggy Stardust alter-ego, a bizarrely androgynous alien from 1972 with hair by Susie Fussey, is a sublime example of the power of the image. Fussey was a stylist at the Evelyn Paget salon in Beckenham High Street, and constructed one of the most famous haircuts in music by combining a selection of different styles that she had sourced from the pages of *Vogue*. Bowie's hair was then dyed a livid orange with *Hot Red* hair dye. Angie, his wife at the time, remarked: 'This new, streamlined, red puffball upped the ante. Now he looked stronger and wilder – just as beddable but a lot stronger and sluttish'. Bowie added: 'I feel very butch now.'[97] On tour, Bowie combined his proto-mullet cut with a variety of outlandish costumes that paved the way for the mainstream acceptance of glam rock, describing them as 'astral West Side Story outfits, with sequins and short battle dress jackets and long patent leather boots.'[98] For the Aladdin Sane tour of 1973 he combined the cut with costumes by Japanese fashion designer Kansai Yamamoto. These were based on the traditional theatre of Noh and Kabuki, where garments are designed to be torn apart to reveal secondary layers underneath. His appearance in a white kimono offset by gold lipstick and orange hair was a seminal moment in the acceptance of androgyny in rock, and his mullet was copied by a generation of men in the 1980s – the contribution of the mullet to American culture was examined in the film *Joe Dirt* of 2001. Dubbed the Guido, or 'business at the front, party at the back' hairstyle, the mullet was adopted by a number of celebrities that included DJ Pat Sharp, cricketer Ian Botham and footballer Chris Waddle. Waddle, however, missed a crucial penalty in England's World Cup semi-final against Germany in 1990, and thus helped the style's demise.

Today, many celebrities have attained their stratospheric status because of how they look as much as anything else. Meg Ryan

above

Singer Kylie Minogue's rebranding as a sex kitten possessed of a beautiful behind ignores the fact that her textured hair has promoted a change from the long ironed look for young women that has held sway since the 1990s. (2002)

left

Actress, model and producer Liz Hurley in her personal uniform of blown-out 'bedhead' hair and revealing Versace gown. Worn with a pair of Jimmy Choo stilettos, this has become her trademark look for parties and premieres. (1999)

above left

Model Kate Moss's West London bohemian style was one of the most copied of the early 2000s, in particular her peroxide 1980s-inspired cut by James Brown and the ubiquitous parka jacket. (2000)

above right

Actress Gwyneth Paltrow in pink Versace and blonde chignon at the 1999 après Oscar party held by Vanity Fair **every year. She achieved the pared-down style of Grace Kelly in the 1950s.**

is as revered for her choppy bob hairstyle as for her roles in *Sleepless in Seattle* (1993) and *You Got Mail* (1998), and Liz Hurley has made a career out of glamorous gowns by Gianni Versace and a mid-length 'bedhead' hairdo. We look to celebrities to inspire us as much as ever – whether it's Kylie Minogue, Gwyneth Paltrow, P Diddy, Tom Cruise, David Beckham, Kate Moss or Jennifer Lopez – and for them the pressure is on to appear perfect on the red carpet under our intense scrutiny. For them hair can make (or break) a career.

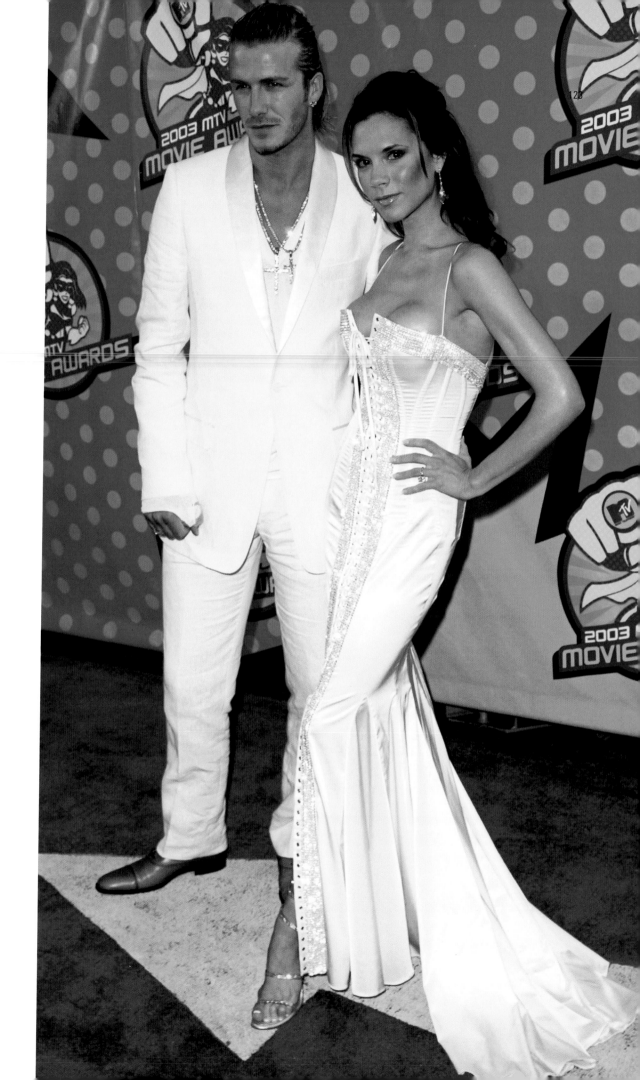

right

**England footballer David Beckham,
as well known for his haircuts
as his athletic skills, has inspired
men in the 2000s to be more
creative with their hair. Victoria
Beckham, meanwhile, is more
conventional than creative in her
hairstyle choices.** (2001)

Notes

INTRODUCTION

1 *Ntozake Shange in Harris, Juliette and Pamela Johnson.* Tenderheaded: A Comb-Bending Collection of Hair Stories *(New York: Pocket Books, 2001), xvii*

2 *Alexandre in Collins, Amy Fine and Antoinette White.* Hair Style *(New York: HarperCollins, 1995), p. 22*

3 *Lewis, Leonard.* Leonard of Mayfair *(London: Hutchinson, 2000), p. 98*

4 *de Villeneuve, Justin.* An Affectionate Punch *(London: Sidgwick and Jackson, 1986), p. 44*

5 *Lewis, p. 102*

6 *Shrimpton, Jean.* An Autobiography *(London: Ebury Press, 1990), p. 39*

7 *Sassoon, Vidal.* Sorry I Kept you Waiting, Madam *(London: Cassell and Co.Ltd, 1968), p. 114*

8 *Lewis, p. 36*

9 *Shrimpton, p. 40*

10 *Lewis, p. 35*

11 *Sam McKnight in Collins and White, p. 103*

12 *Zdatny, Stephen.* Hairstyles and Fashion: A Hairdresser's History of Paris 1910–1920 *(Oxford: Berg, 1999), p. 2*

LONG

13 *Haiku in Ebersole, Gary L.,* "'Long black hair like a seat cushion": Hair Symbolism in Japanese Popular Religion', *in (eds) Hiltebeitel, Alf and Barbara D. Miller,* Hair: Its Power and Meaning in Asian Cultures *(Albany, State University of New York Press, 1998), p. 95*

14 *Lang, Karen,* 'Shaven Heads and Loose Hair: Buddhist Attitudes towards Hair and Sexuality' *in (eds) Eilberg-Schwartz, Howard and Wendy Doniger,* Off with her Head: The Denial of Women's Identity in Myth, Religion and Culture *(Berkeley, University of California Press, 1995), p. 38*

15 *Zdatny, Stephen.* Hairstyles and Fashion: A Hairdresser's History of Paris, 1910–1920 *(Oxford: Berg, 1999), p. 19*

16 *Ibid.*

17 *Trasko, Mary.* Daring Do's: A History of Extraordinary Hair *(Paris: Flammarion, 1994), p. 102*

18 *Anon,* The Habits of Good Society: A Handbook of Etiquette for Ladies and Gentlemen *(London, J. Hogg and Sons, 1859), p. 14*

19 *Mick Jagger in Foote, Shelly,* 'Challenging Gender Symbols', *in (eds) Brush-Kidwell, Claudia and Valerie Steele,* Men and Women: Dressing the Part *(Washington, Smithsonian Institution Press, 1989), p. 153*

20 *Bruce Jay Friedman in Foote, p. 154*

21 *Frank Dikotter,* 'Hairy Barbarians, Furry Primates, and Wild Men: Medical Science and Cultural Representations of Hair in China', *in Hiltebeitel and Miller, p. 52*

22 *David Horowitz,* '1968 and all that', *Independent on Sunday, 8 February 1998, p. 12*

23 *David Bowie in Odell, Michael,* The Unkindest Cuts of All, *Daily Express, 19 June 2000*

24 *Fogg, Marnie,* Boutique: a 60's Cultural Phenomenon *(London, Mitchell Beazley, 2003), p. 164*

COLOUR

25 *Chandler, Raymond.* Farewell My Lovely. *(London: Penguin, 1949), p. 84*

26 *Montgomery, Lucy Maud.* Anne of Green Gables *(1925; London: Puffin, 1994), p. 20*

27 *Zdatny, Stephen.* Hairstyles and Fashion: A Hairdressers' History of Paris *(Oxford: Berg, 1999), p. 17*

28 *Corson, Richard.* Fashions in Hair: The First Five Thousand Years *(1965; London: Peter Owen, 2000), p. 602*

29 *Ron Levin in Gladwell, Malcom,* 'Message in a Bottle', *Independent on Sunday, 27 June 1999*

30 *Corson, Richard.* Hair: The First 5,000 Years *(London: Peter Owen, 1965), p. 629*

31 *Lewis, Leonard.* Leonard of Mayfair *(London: Hutchinson, 2000), p. 114*

32 *Siouxsie Sioux in Jones, Dylan.* Haircults: Fifty Years of Styles and Cuts *(London: Thames and Hudson, 1990), p. 87*

33 *Cooper, Wendy.* Hair: Sex, Society, Symbolism. *(London: Aldus Books, 1971), p. 76*

CUT

34 *Pond, Mimi.* Splitting Hairs: The Bald Truth about Bad Hair Days *(New York, Fireside, 1998), p. 64*

35 *Antoine.* Antoine by Antoine *(New York: Prentice-Hall, 1945), pp. 92–3*

36 *Trasko, Mary.* Daring Do's: A History of Extraordinary Hair *(Paris: Flammarion, 1994), p. 112*

37 *Simon, Diane.* Hair: Public, Political, Extremely Personal *(New York: St Martin's Press, 2000), p. 27*

38 *Cecil Beaton in Hulton-Getty,* Attitude: Hairdos *(London: MQ Publications Ltd, 1999), p. 49*

39 *Corson, Richard.* Hair: The First 5,000 Years *(London: Peter Owen, 1965), p. 615*

40 *Dior in Cox, Caroline,* I Do: 100 Years of Wedding Fashion *(London: Scriptum, 2002), p. 122*

41 *Sassoon, Vidal.* Sorry I Kept You Waiting Madam *(London: Cassell and Co. Ltd, 1968), p. 9*

42 *Polhemus, Ted and Lynn Procter.* Pop Styles *(London: Vermilion and Co., 1984), p. 9*

43 *Lewis, Leonard.* Leonard of Mayfair *(London: Hutchinson, 2000), p. 92*

44 *Hulton-Getty.* Attitude: Hairdo *(London: MQ Publications Ltd, 1999), p. 40*

45 *York, Peter.* Modern Times *(London: Futura, 1984),
 p. 72*

46 *Vishnoo @ http://www.boogietown.netforums*

CURLY

47 *Hannah Pool, 'The New Black',* The Times,
 22 February 2003

48 *Emile Long in* Hairdresser's Weekly Journal,
 March 1917

49 *Antoine.* Antoine by Antoine *(New York: Prentice-
 Hall, 1945), p. 158*

50 Hairdresser's Weekly Journal, *March 1909*

51 *Willett, Julie A.* Permanent Waves: The Making of
 the American Beauty Shop *(New York: New York
 University Press, 2000), pp. 92–3*

52 *Dengel, Veronica.* Can I Hold My Beauty? *(London:
 John Westhouse Publishers Ltd, 1946), p. 29*

53 *Landvik, Lorna,* Patty Jane's House of Curl. *(London:
 Viking, 1997), p. 1*

54 *Robert Plant. http://www.naturallycurly.com*

55 *Kirsch, Michele, 'Let's Get it Straight, Curls are
 History',* Independent on Sunday, *27 June 1993*

FAKE

56 *Rapper Mace.* We Both Frontin'. *(New York: Harlem
 World, 1999)*

57 *Hardy, Lady Violet.* As It Was *(London: Christopher
 Johnson, 1958), p. 79*

58 Hairdresser's Weekly, *16 July 1910, p. 118*

59 *Alcott, Louisa May,* Little Women *(1886; London: The
 Childrens' Press, 1963), p. 129*

60 *Jones, Dylan,* Haircults: Fifty Years of Styles and
 Cuts *(London, Thames and Hudson, 1990), p. 47*

61 *Ibid., p. 101*

62 *Ibid.*

CATWALK

63 *Nathalie Khan in Bruzzi, Stella and Pamela Church
 Gibson (eds).* Fashion Cultures: theories,
 explorations and analysis *(London: Routledge, 2000),
 p. 144*

64 *Thurlow, Valerie.* Model in Paris *(London: Hale,
 1975), p. 9*

65 *Dawnay, Jean.* Model Girl *(London: Weidenfeld and
 Nicholson, 1965), p. 168*

66 *Ibid.*

67 *Anne Gunning in Castle, Charles,* Model Girl
 (Newton Abbot: David and Charles, 1977), p. 38

68 *Sassoon, Vidal.* Sorry I Kept you Waiting, Madam
 (London: Cassell and Co. Ltd, 1968), p. 70

69 *Mary Quant in Sassoon, p. 121*

70 *Ibid.*

71 *Thurlow, p. 34*

72 *Palau, Guido.* Heads: Hair by Guido *(London:
 Booth-Clibborn Editions Ltd, 2000), Preface*

73 *Liz Tilberis in Collins, Amy Fine and Antoinette White,*
 Hair Style *(New York: HarperCollins, 1995), p. 9*

74 *Ibid.*

75 *Stephen Sprouse in Collins, p. 30*

76 *Eugene Souleiman in When Vidal met Eugene, Vidal
 Sassoon Autumn/Winter 2000, p. 18*

77 *Palau, 2000*

STREET

78 *Polhemus, Ted.* Street Style: From sidewalk to
 catwalk *(London: Thames and Hudson, 1994), p. 6*

79 *Tony Curtis in Jones, Dylan,* Haircults: Fifty Years of
 Styles and Cuts *(London, Thames and Hudson, 1990),
 p. 22*

80 *Ray Gosling in Fogg, Marnie,* Boutique: a 60's
 Cultural Phenomenon *(London, Mitchell Beazley,
 2003), p. 58*

81 *Tarrant, Chris.* Rebel, Rebel: Twenty-five Years of
 Teenage Trauma *(London: Pyramid Books, 1991),
 p. 17*

82 *Fogg, p. 63*

83 *MacInnes, Colin.* Absolute Beginners *(London: Allison
 and Busby, 1980), p. 62*

84 *Barnes, Richard.* Mods! *(London: Plexus, 1991), p. 11*

85 *Boy George.* Take it Like A Man: The
 Autobiography of Boy George *(London: Pan Books,
 1995), p. 79*

86 *Ibid.*

87 *Tarrant, p. 133*

88 *Boy George, p. 175*

89 *Tilley, Sue.* Leigh Bowery: The Life and Times of
 an Icon *(London: Sceptre, 1997), pp. 31–2*

90 *Ibid., p. 103*

91 *Cross, Charles R.* Heavier Than Heaven: A
 Biography of Kurt Cobain *(London: Hodder and
 Stoughton, 2001), p. 2*

CELEBRITY

92 *Dyer, Richard.* Stars *(London: B.F.I. Publishing, 1998),
 p. 220*

93 *Stacey, Jackie.* Star Gazing: Hollywood and Female
 Spectatorship *(London: Routledge, 1994), p. 145*

94 *Dyer, p. 43*

95 *York, Peter.* Modern Times *(London: Futura, 1984),
 p. 24*

96 *Ibid.*

97 *David Bowie in Odell, Michael, 'The Unkindest Cuts
 of All',* Daily Express, *19 June 2000*

98 *Ibid.*

Acknowledgements

Caroline Cox and Lee Widdows would like to thank L'Oréal Professionnel for their enthusiastic support of *Hair and Fashion*. Special thanks go to Bertrand Fontaine, Mai-Britt Rasmussen and Naomi Scroggins.

We would also like to thank everyone who has helped with and worked on the book, especially Professor Margaret Buck, Caroline Evans, Dr Joan Farrar, Jane M. Rapley OBE, Chris New, Mike Sossick and Willie Walters of Central Saint Martins College of Art and Design, School of Fashion and Textile Design, University of the Arts.

We are extremely grateful to Mary Butler, Monica Woods, Clare Davis and Catherine Blake of V&A Publications, Marnie Fogg, Maggie Norden, Khalid Siddiqui, Lionel Marsden, Tim Hartley, Stephen Mackinder, Kathy Phillips and Jacki Wadeson. Thanks also to Vaughan Oliver at V23 for the book design, Dominic Davies for original photography, David West and Martin Spencer at Studio 22 and special thanks to Hywel Davies for picture research.

Picture credits

Index

Index